Through The Eye
Of My Lens

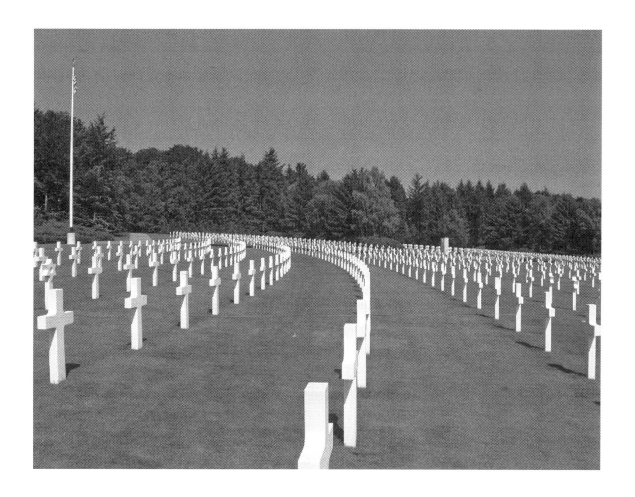

Joseph Hendrix

Joseph Hendrix Photography

Through The Eye Of My Lens

Joseph B. Hendrix

. . . . a series of coffee table books

March 2011

authorHOUSE®

AuthorHouse™
1663 Liberty Drive
Bloomington, IN 47403
www.authorhouse.com
Phone: 1-800-839-8640

First published by AuthorHouse 09/29/2011

ISBN: 978-1-4567-6970-3 (sc)

Library of Congress Control Number: 2011907930

Printed in the United States of America

Dedication

I would like to dedicate this book to my wife Diana and my daughter Chelsea; because, without them there would be no reason to continue.

—I love you both very much!

Photographer—Joseph Hendrix

Luxembourg

World War II

American Cemetery

The Luxembourg American Cemetery and Memorial is situated in a beautiful wooded area in Luxembourg City, Luxembourg. The cemetery was established on December 29, 1944 by the 609th Quartermaster Company of the U.S. Third Army while Allied Forces were stemming the enemy's desperate Ardennes Offensive, one of the critical battles of World War II. The city of Luxembourg served as headquarters for General George S. Patton's U.S. Third Army. General Patton is buried here.

Not far from the cemetery entrance stands the white stone chapel, set on a wide circular platform surrounded by woods. It is embellished with sculpture in bronze and stone, a stained-glass window with American unit insignia, and a mosaic ceiling. Flanking the chapel at a lower level are two large stone pylons upon which are maps made of various inlaid granites, with inscriptions recalling the achievements of the American armed forces in this region. On the same pylons are inscribed the names of 371 of the missing. Rosettes mark the names of those since recovered and identified.

Sloping gently downhill from the memorial is the burial area containing 5,076 of our military dead, many of whom lost their lives in the "Battle of the Bulge" and in the advance to the Rhine. Their headstones follow graceful curves; trees, fountains and flower beds contribute to the dignity of the ensemble.

www.josephhendrixphotography.com

http://josephhendrixphotography.blogspot.com

Epigraph

Both the grand and the intimate aspects of nature can be revealed in the expressive photograph. Both can stir enduring affirmations and discoveries, and can surely help the spectator in his search for identification with the vast world of natural beauty and the wonder surrounding him.

—"Ansel Adams"

Warning—Disclaimer

This book is designed to provide information on my travels throughout United States, Europe and Africa. The Coffee Table Book is sold with the understanding that the publisher and author are not engaged in rendering legal, accounting or other professional services. If legal or other expert assistance is required, the services of a competent professional should be sought. It is not the purpose of this book to reprint all the information that is otherwise available to authors and/or publishers, but instead to complement, amplify and supplement other texts.

You are urged to read all the available material, learn as much as possible about the beautiful and exciting places I have been. Tailor the information to your individual needs. Self-publishing is not a get-rich-quick scheme. Anyone who decides to write and publish a book must expect to invest a lot of time and effort into it. For many people, self-publishing is more lucrative than selling manuscripts to another publisher, and many have built solid, growing, rewarding businesses. Every effort has been made to make this manual as complete and as accurate as possible.

However, there *may be mistakes*, both typographical and in content. Therefore, this text should be used only as a general guide and not as the ultimate source of writing and publishing information. Furthermore, this manual contains information places and things on writing and publishing that is current only up to the printing date.

Joseph Hendrix and AuthorHouse Book Publishing Company shall have neither liability nor responsibility to any person or entity with respect to any loss or damage caused, or alleged to have been caused directly or indirectly, by the information contained in this book.

If you do not wish to be bound by the above, you may return this book to the publisher for a full refund.

St Wolfgang, Austria

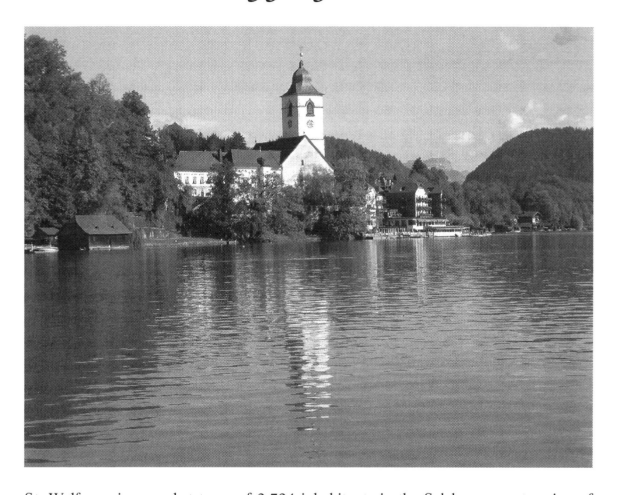

St. Wolfgang is a market town of 2,794 inhabitants in the Salzkammergut region of Upper Austria, named after Saint Wolfgang of Regensburg. The complete name of the town is Sankt Wolfgang in Salzkammergut. Situated on the northern shore of the Wolfgangsee (close to the towns of Strobl and St.Gilgen, both in the State of Salzburg) at the foot of the Schafberg mountain, it is famous for the White Horse Inn (Hotel Weißes Rössl), the setting of the musical comedy and for its pilgrimage church with a late Gothic altarpiece by Michael Pacher.

A destination spa, St. Wolfgang is also a popular skiing resort during the winter. A rack railway, the Schafbergbahn runs up the mountain. There had been several places for lodging around the church since medieval times. The Weißes Rössl hotel was built in1878. There had been several places for lodging around the church since medieval times, while the Weißes Rössl hotel was not built before 1878. During World War II, a sub-camp of the infamous Dachau concentration camp was located here which was liberated by the American Army.

Horst Castle, Belgium

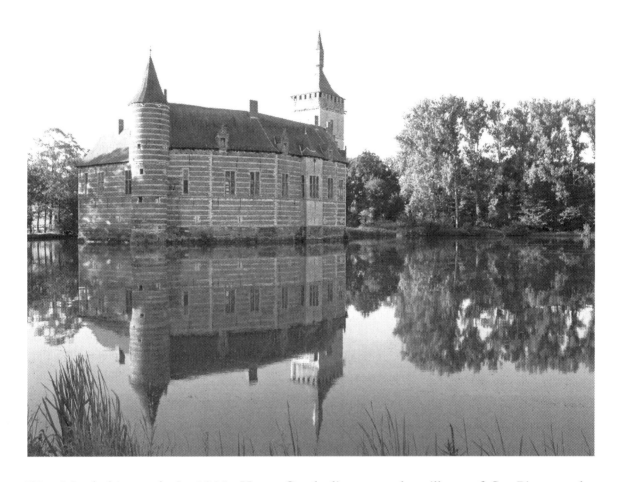

We visited this castle in 2008. Horst Castle lies near the village of St. Pietersrode, north-east of the city of Brussels, Belgium. When the first Horst Castle was built isn't known. And however there was a 'castellum Rode' in this area in the 11th century, the name Horst was first mentioned in 1263. Then, a Jan van Thunen settled here and called himself Jan van Horst.

Horst Castle was built on a strategic spot in the Winge-valley and was one of the strengths protecting the nearby city of Leuven which was the largest and most important city in the Duchy of Brabant during the 14th century. In 1369 the castle was bought by an Amelric Boote who rebuilt it. Of his stronghold only the keep, part of the curtain wall and a part of the gate remains. In 1488/89 the castle was burnt down by the people of Leuven during their war against Maximillian of Austria. Around 1490 the castle was rebuilt to its present appearance.

Verdun, France

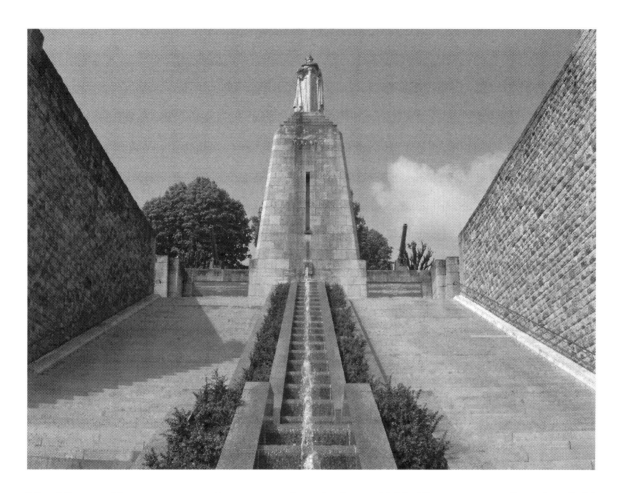

The Victory Monument was inaugurated on 23 June 1929. There are two Russian field guns at the front of the monument which had been captured by the Germans and then taken from them by the French Army. This monument with its 73 steps leads to a statue of a soldier at the top. The steps are carved into the old ramparts of Verdun. In the crypt below visitors can see the books with all the names of those who received medals from Verdun. Leading away from the river here are several roads, and one of these gives an outstanding view up to the Victory Monument. This imposing monument is set into the town walls, and small fountains flow in the street leading up to it, and in the middle of the steps which lead up to it.

At the top of the steps is a 90 foot tall column which stands the figure of a knight and a pair of Russian field guns which flank the column. There are annual commemorations here in June each year; which are amazing events.

Queen's Guard—London Tower—London, England

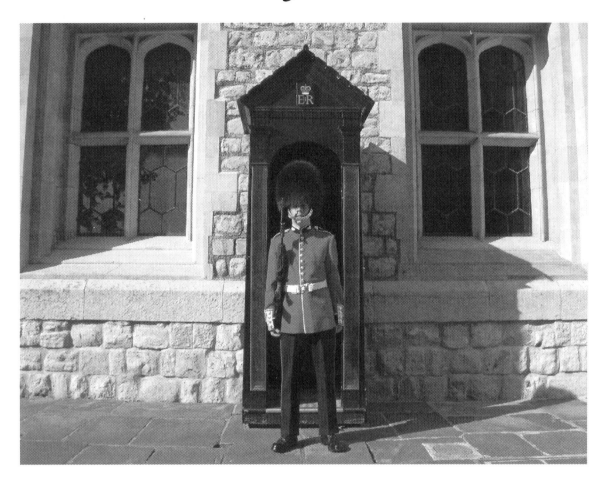

Her Majesty's Royal Palace and Fortress, more commonly known as the Tower of London, is a historic castle on the north bank of the River Thames in central London, England. It lies within the London Borough of Tower Hamlets, separated from the eastern edge of the City of London by the open space known as Tower Hill. It was founded towards the end of 1066 as part of the Norman Conquest of England. The Queen's Guard and Queen's Life Guard are the names given to contingents of infantry and cavalry soldiers charged with guarding the official royal residences in London.

The British Army had regiments of both Horse Guards and Foot Guards predating the English Restoration (1660), and since the reign of King Charles II these have been responsible for guarding the Sovereign's palaces. A detachment of the Regiment on guard at Buckingham Palace and St James's Palace is also responsible for providing the guard at the Tower of London.

La Petite France—Strasbourg, France

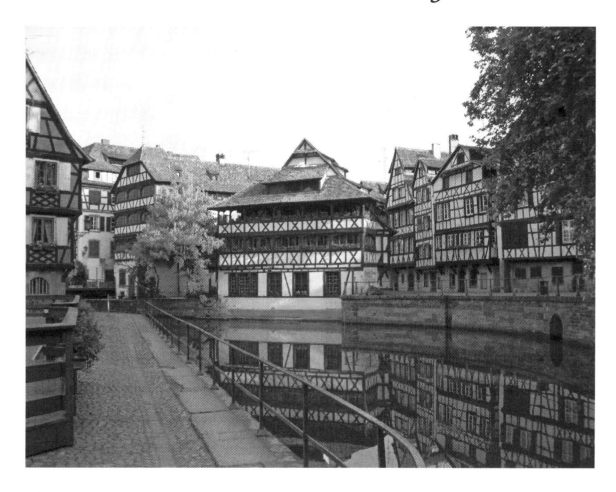

The most picturesque part of Strasbourg is La Petite France (Little France). This area is on islands in the Ill River and full of postcard-perfect scenes. Most buildings have half-timbered structures with balconies where ample geraniums flower to add color to an already far from bland area. Inviting restaurants adds to the appeal of this area. The Ponts Couverts (Covered Bridges) are a series of bridges over the four arms of the Ill River just south of the La Petite France. Three watchtowers survived from the original medieval town defenses.

The best views of the bridges and old town is from the terrace at the Grand Ecluse—a late seventeenth-century (but frequently changed) dam built to update the town defenses. Strasbourg's historic Le Petite France neighborhood is a serene collection of cobblestone roads, fine restaurants and medieval buildings. Fine dining and good shopping abound in this part of town.

German Hobo—Partenkirchen, Germany

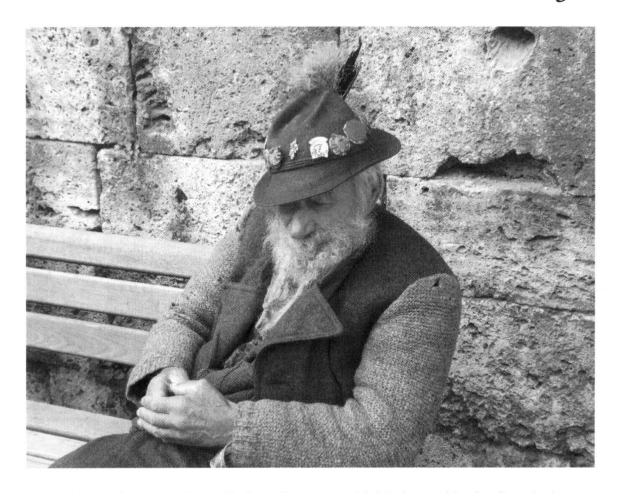

I met this gentleman in Partenkirchen, Germany which is located in the Garmisch area. Have you ever seen those people playing music in the market place in Germany, or how about those living statues? How about those people who hold out their hands expecting you to give them a few coins? This gentleman was satisfied with just hanging out on that sunny day. How many homeless people exist in Germany? Believe it or not, there are actually around 860,000 homeless people in Germany. The numbers of homeless in Germany are not registered in any governmental statistics; the only estimates were made by independent institutions offering social services.

There are shelters in Germany and places for these people to get help. Many times I see them drinking outside of supermarkets or sitting along side a building begging for money. Rather than give them money I would rather give them food so at least I know they won't use the money for the wrong things.

Chateau de Walzin, Belgium

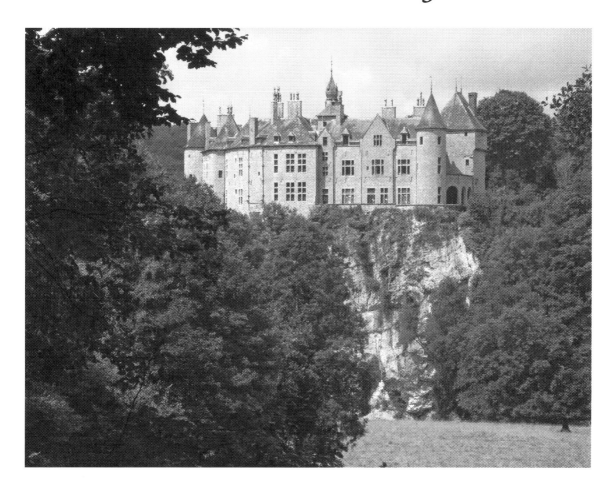

I remember walking for hours and traversing to the right angle in which to take this image. The impressive castle of Walzin is fabulously situated on a rocky cliff high above the river Lesse as a real eagle's nest! Originally built in the 11th century, massive restoration works took place in the 19th and 20th century because of the many incessant conflicts that to place during the wars of 1489, 1554 and 1581 which brought many new waves of destruction.

The castle was initially built to serve as a supervisory position and forward defense to the town of Dinant, Belgium and was the only access from the south to Dinant was through the Ford of Walzin. The white cliff rises directly from the water, sheer and majestic; like that which is crowned by the romantic Chateau Walzin which is sometimes more broken and rises amidst trees from a broad emerald meadow that is interposed between its base and the windings of the river below.

Stari Most (Old Bridge), Bosnia Herzegovina

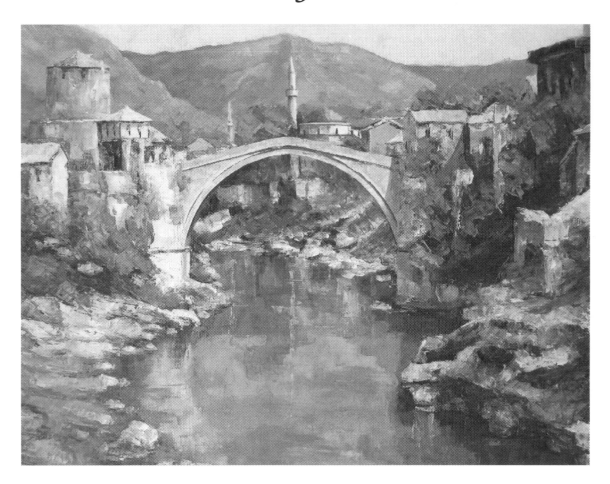

Stari Most (Old Bridge) is a 16th century Ottoman bridge in the city of Mostar, Bosnia and Herzegovina that crosses the river Neretva and connects two parts of the city. The original bridge was commissioned in 1557 to replace an older wooden suspension bridge of dubious stability. Construction began in 1557 and took nine years. According to the inscription, the bridge was completed in 974, corresponding to the period between July 19, 1566 and July 7, 1567. The Old Bridge stood for 427 years, until it was destroyed on November 9, 1993 during the Croat-Bosniak War. Subsequently, a project was set in motion to reconstruct it, and the rebuilt bridge opened on July 23, 2004.

It is traditional for the young men of the town to leap from the bridge into the Neretva. As the Neretva is very cold, this is a very risky feat and only the most skilled and best trained divers will attempt it. The rewards are endless for the divers, as the hundreds of passers-by donate quite well to their cause.

Lorraine WW II American Cemetery— St Avold (Alsace Lorraine), France

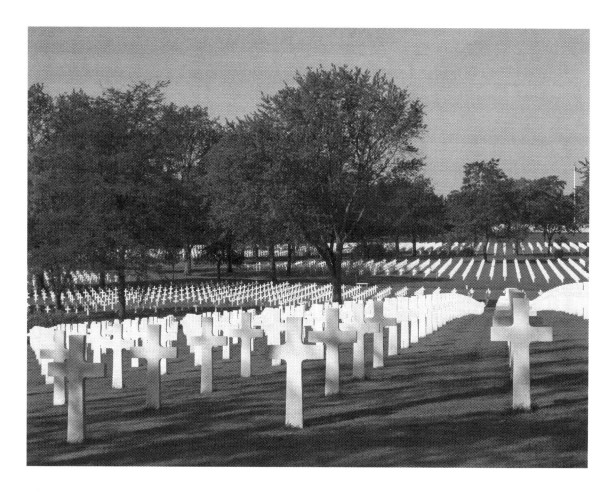

The Lorraine American Cemetery and Memorial in France covers 113.5 acres and contains the largest number of graves of our military dead of World War II in Europe, a total of 10,489. Their headstones are arranged in nine plots in a generally elliptical design extending over the beautiful rolling terrain of eastern Lorraine and culminating in a prominent overlook feature.

Most of the dead here were killed while driving the German forces from the fortress city of Metz toward the Siegfried Line and the Rhine River. Initially, there were over 16,000 Americans interred in the St. Avold region, mostly from the U.S. Seventh Army's Infantry and Armored Divisions and its Cavalry Groups. St. Avold served as a vital communications center for the vast network of enemy defenses guarding the western border of the Third Reich.

Hochosterwitz Castle, Austria

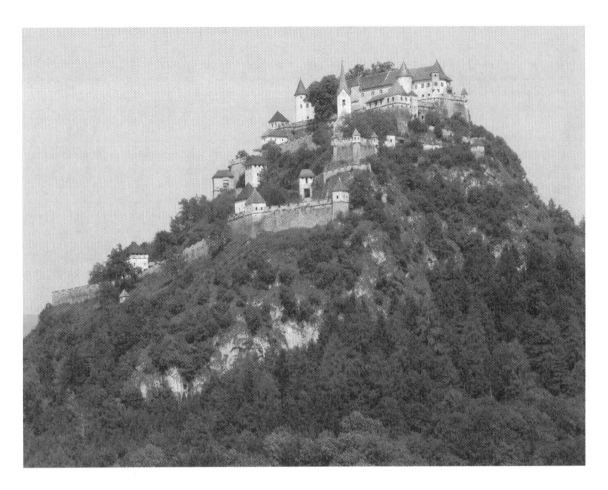

Hochosterwitz Castle is considered to be one of Austria's most impressive medieval castles. It is situated on a 160 meter Dolomite rock near Saint Georgen am Längsee, east of the town of Saint Veit an der Glan in the state of Carinthia which is in southern Austria. The castle is one of the state's landmarks and can be seen from about 30 kilometers away on a clear day. Since the 16th century, no major changes have been made to Hochosterwitz. It has also remained in the possession of the Khevenhüller family as requested by the original builder, George Khevenhüller.

Some parts of the castle are open to the public every year from Easter to the end of October. Tourists are allowed to walk the 620 meters long pathway through the 14 gates up to the castle. Hochosterwitz Castle can be reached by car or an easy hike from the Saint Veit an der Glan train station, with connection to nearby Klagenfurt which borders with the country of Slovenia.

Chateau Fort de Feluy, Belgium

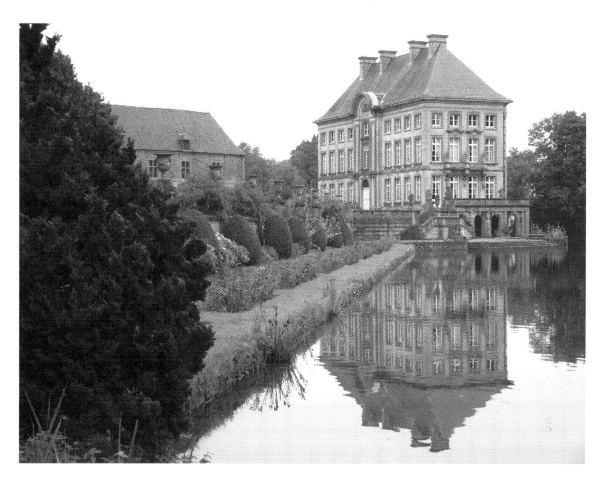

You can find the castle of Feluy in the village of the same name. The castle is private property but it can be viewed from the public road. From 1380 to 1548, the Feluy Estate belonged to the Bousies family. It then passed to the Rubempré family until 1576 and after that to the Berghe family, in whose possession it remained for a century. It was subsequently abandoned and bought in 1774 by the Countess Ysendoorn de Blois.

Around 1777, she had the building restored in keeping with the fashion of the day. Around 1940, a final restoration was carried out by the architect Puttemans. Today, the Château de Feluy comprises two separate buildings, a fortified wing and residential main building. Both are surrounded by moats that form a pond behind the château which are fed by the River Graty. Because of the wars through the centuries, the castle suffered a lot of damage and was also neglected.

Leers-et-Fosteau castle—THUIN, Belgium

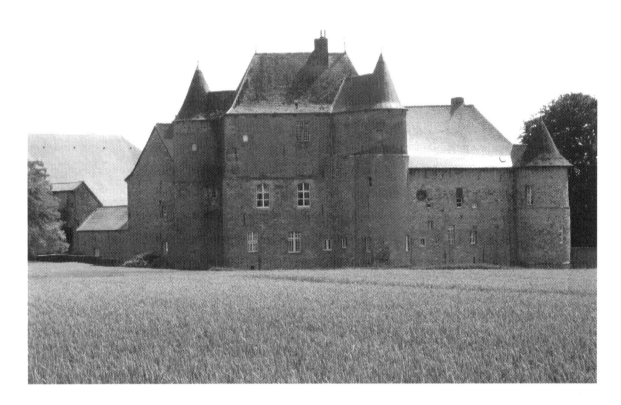

Castle Fosteau is located in Leers-et-Fosteau in the municipality of Thuin, province of Hainaut, in Belgium. At the summit of an undulation the silhouette of the castle of Fosteau appears. This imposing fortress from the 14th century still has got 4 towers. The lords of Semousies, Sars, and after them the lords of Zwenne, Marotte, de Henry, de Jamblines and de Aoust developed the living quarters around the central tower of the castle. Inside is one of the finest gothic rooms in Belgium.

The beautiful and sober French gardens lie out in a terrace and go as far as the lake. This amazing castle has been considered a monument since 1979. The Castle of Fosteau appears to have a split personality—the lower half of the building is made from grey limestone, while most upper parts are made of red brick. The limestone base dates from the 14th and 15th centuries; the brick portions were grafted on in 1599. Fosteau is open to the public several days each week. Parts of the castle serve as an antique showroom.

Zugspitze Chapel—German Alps

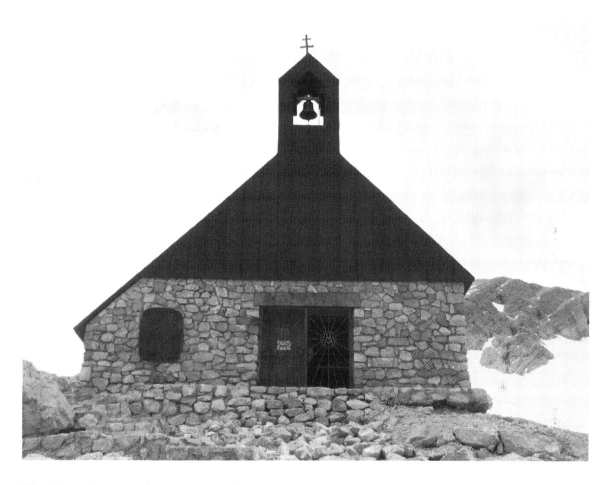

The Zugspitze, at almost 10,000 feet or 3,000 meters, is the highest peak in the Bavarian Alps chain. On a clear day, from the summit you can see four countries—Germany, Austria, Switzerland and Italy! When you visit, you will have an experience to remember. Our last trip to the Bavarian Alps in early October included a day trip to the Zugspitze.

When you arrive on the top of the Zugspitze and take a look around, you will be amazed at the view of the surrounding Alps. Up the hill is Germany's highest (altitude) chapel. The views of the Alps from here are awesome, as you wander around during some nice "easy" walks. You can really enjoy nature and see the lovely mountain flowers during the spring and summer months. We had lunch up on the mountain and it was really nice sitting there, looking into the distance and just daydreaming. NOTE: ensure you travel to the top on a partly cloudy to sunny day, as you may find yourself arriving in the fog which will ruin your day.

Dubrovnik, Croatia (former Yugoslavia)

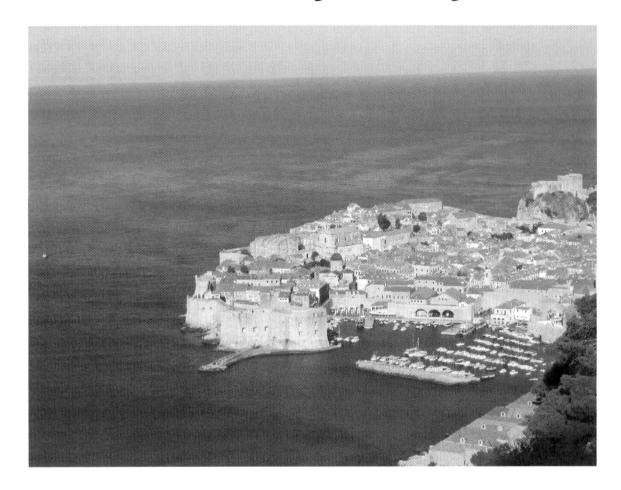

Dubrovnik is located in the extreme southern most part of Croatia on the Dalmatian coast in the Adriatic Sea. It is a port, tourist and cultural center with some light industries. Dubrovnik was founded in the 7th century by Romans fleeing Slavic incursions. Later, however, the Slavic people settled in the city which became a link between both the Latin and Slavic civilizations. Dubrovnik became a powerful merchant republic; although it was a protectorate of the Byzantine Empire until 1205, of Venice until 1358, of Hungary until 1526, and of the Ottoman Empire until 1806.

It remained virtually independent until it was abolished in 1808 by Napoleon the 1st. In 1815, the Congress of Vienna assigned it to Austria and in 1918, it was included in what became Yugoslavia. It suffered a severe earthquake in 1667 but retains much of its medieval architecture today. The city was heavily damaged in fighting that followed Croatia's secession from Yugoslavia in 1991.

Normandy American Cemetery and Memorial

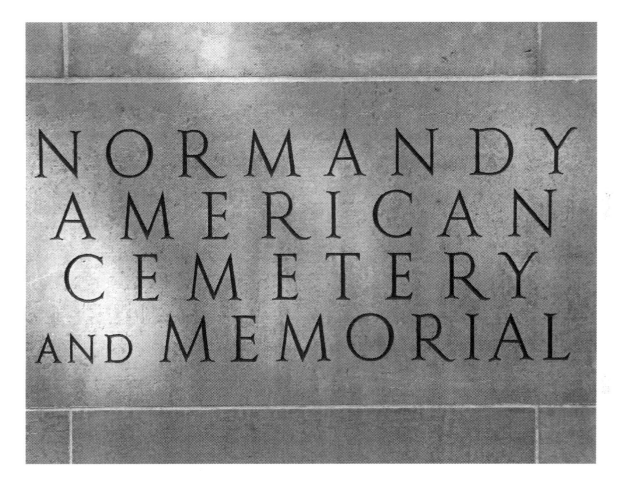

The Normandy American Cemetery and Memorial is a World War II cemetery and memorial in Colleville-sur-Mer, Normandy, France, that honors American soldiers who died in Europe during World War II. The cemetery is located on a bluff overlooking Omaha Beach (one of the landing beaches of the Normandy Invasion) and the English Channel. It covers 70 hectors (172 acres), and contains the remains of 9,387 American military dead, most of who were killed during the invasion of Normandy and ensuing military operations in World War II. Included in the cemetery are graves of Army Air Force crews shot down over France as early as 1942.

Only some of the soldiers who died overseas in Normandy during WW II were buried in the overseas American military cemeteries. When it came time for a decision, the distraught family members had to determine if they wanted their loved ones buried in an overseas military cemetery—most families chose to.

Chateau Carrouges—Normandy, France

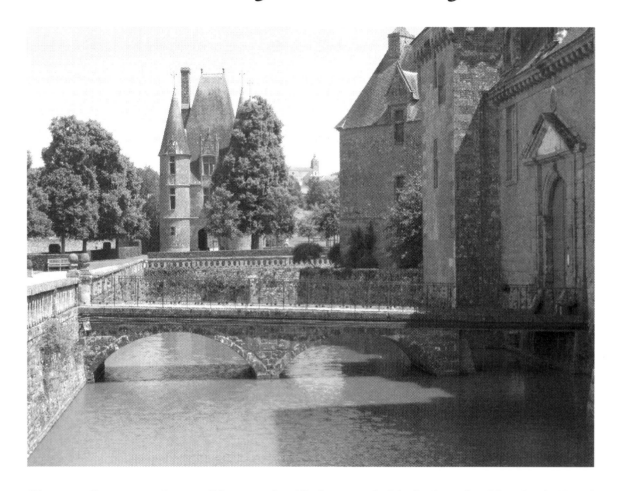

Chateau Carrouges began life as a fortified stronghold during the Hundred Years' War—the keep is seen in the corner of the inner courtyard. It became a lordly residence in the 15th century for the Blosset family and was extended with the addition of a residential wing next to the keep. In the 16th century the wonderful gatehouse was added, like a château in miniature—this is considered to be the earliest piece of Renaissance architecture in Normandy.

Carrouges was refortified during the Wars of Religion with the construction of the west bastion, and finally in the late 16th century two 'classical' wings with remarkable staircases were added. The Blosset de Tillier family owned the château and estate from the end of the 15th century until 1936, when the chateau and much of the furniture was purchased by the State as a historic monument. One of the most distinctive features of the Château de Carrouges is the fact that it is largely made of brick due to the presence of local clay.

Hohenzollern Castle, Germany

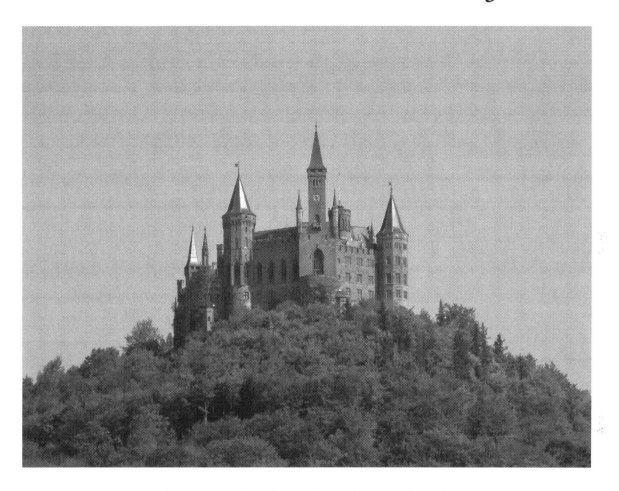

The first mention of the House of Hohenzollern dates back to the year of 1061. Their ancestral seat; however, was first documented not until 1267 as "Castro Zolre". The appearance, extent and furnishings of the original castle were supposedly built in the first half of the 11th century. It must have been a vast complex; however, since contemporary sources then described it as "the crown of all castles in Swabia" and "the most fortified house in the German territories."

From 1952 on Prince Louis Ferdinand of Prussia (1907-1994) started to furnish the castle with a multitude of valuable works of art and memorabilia dedicated to the history of Prussia and its rulers. The extremely high costs of maintenance and renovations were met by the owners, the heads of the Prussian and the Swabian family branch, themselves which turned out to be a permanent challenge. Each visitor also contributes to the conservation and preservation of Hohenzollern Castle, a heritage landmark and symbol of the German history.

Burg Lichtenstein, Germany

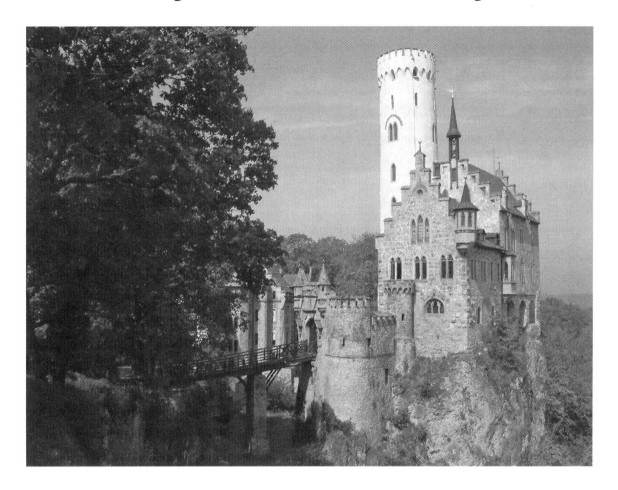

Lichtenstein Castle is situated on a cliff located near Honau in the Swabian Alb, Baden-Württemberg, Germany. It's self-descriptive name in English means "light (colored) stone." Historically there has been a castle on the site since around 1200. It was twice destroyed, once in the Reichskriegs war of 1311 and again by the city-state of Reutlingen in 1381. The castle was not reconstructed and subsequently fell to ruin.

In 1802; the land came into the hands of King Frederick I of Württemberg, who built a hunting lodge there. By 1837 the land had passed to his nephew Duke Wilhelm of Urach, Count of Württemberg who; inspired by Wilhelm Hauff's novel Lichtenstein, added the current castle in 1842. The romantic Neo-Gothic design of the castle was created by the architect Carl Alexander Heideloff. Today the castle is still owned by the Dukes of Urach, but is open to visitors. The castle contains a large collection of historic weapons and armor you need to see to believe.

Schloss Anif—Austria

Anif Castle is charming and located in the town of the same name, which is located about 4 km south of Salzburg. The village itself is a suburb of the city and lies in the Austrian district of Salzburg. Anif Castle was built near the pond on the southern border of Salzburg and is also known as the Water Palace. The first written evidence of the existence of the Anif fortress being here comes from 1520. It is mentioned in the texts as the castle named Oberweiher, which is owned by a local judge contractor. After 1530 the palace was mentioned regularly in feud as it passes into the hands of the Archbishop of Salzburg.

In 1918, public attention was drawn to Anif by the Bavarian King Ludwig III who was hidden in the castle with his family during the November Revolution. By the 19th century, the architecture of the palace in Anif wasn't impressive. In 1838 and 1848; it was completely renovated in neo-Gothic style by the family Johannes Moy. The last major renovation was between 1995 and 2000. Today it is their private property and is not accessible to the community.

Postojna Caves - Predjama Castle, Slovenia

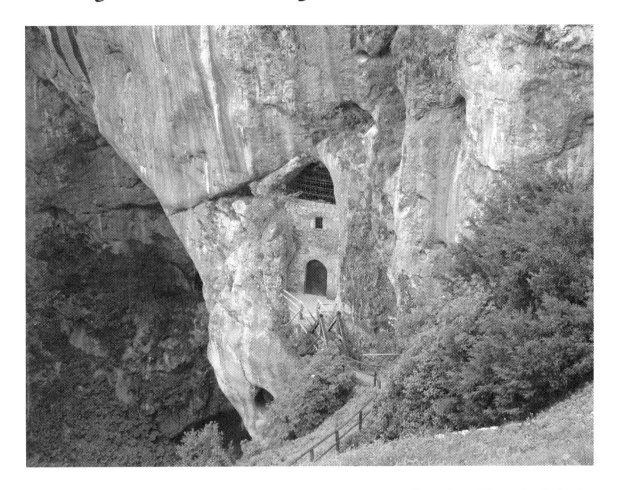

Postojna Cave is a 20,570 m long Karst cave system near Postojna, Slovenia. It is the longest cave system in the country as well as one of its top tourism sites. The caves were created by the Pivka River. The cave was first described in the 17th century by Johann Weichard Valvasor and a new area of the cave was discovered accidentally in 1818 by local Luka Cec, when he was preparing the hitherto known parts of the cave for a visit by Francis I, the first Emperor of Austria. In 1819, the caves were opened to the public, and Cec went on to become the first official tourist guide for the caves.

Electric lighting was added in 1884, preceding even Ljubljana, the capital of Carniola, the Austro-Hungarian province the cave was part of at the time, and further enhancing the cave system's popularity. In 1872 rails were laid in the cave along with first cave train for tourists. At first, these were pushed along by the guides themselves, later at the beginning of the 20th century a gas locomotive was introduced and then the electric locomotive in 1945.

Chateau Feodal de Fernelmont— Fernelmont, Belgium

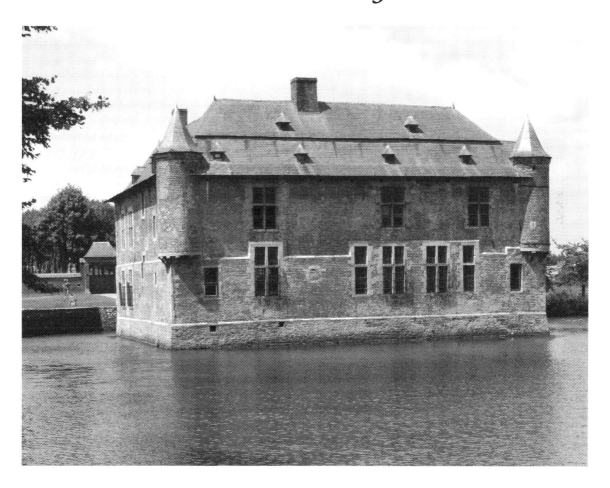

Fernelmont is the name of this medieval castle, ancient seat of a lordship, who was chosen in 1977 to designate the town created by the merger of ten villages that was once mainly an agricultural part of the County of Namur. The Lordship of Freemasonry Waret; a place name that evokes an important Frankish occupation in the region, is mentioned in the thirteenth century.

The original tower was rebuilt in the sixteenth century fortified farmhouse. It passed in 1591 by marriage to the family Groesbeck whose last descendant had built in the second half of the eighteenth century the castle we know today.

Fernelmont is a town located in the north-eastern province of Namur, a region rarely visited by tourists; yet the location is in the beautiful and fertile Hesbaye, Namur. Fernelmont is the most renowned Chateaus in the province.

Eisriesenwelt (Ice Cave)—Werfen, Austria

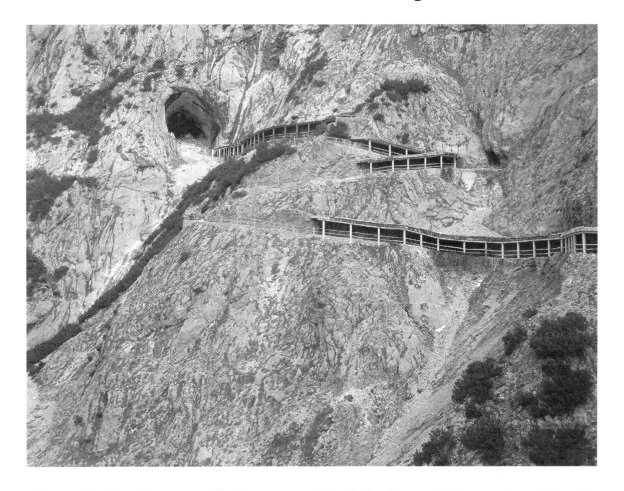

The Werfen Ice Caves actually form a cave labyrinth of over 40 km total path length. Thousands of visitors come to see the icy caves each year, but only one kilometer is open for public visiting. These caves were formed over a long period of time (the first cracks and fissures in the mountains' limestone appeared more than a hundred million years ago), and they are a fantastic display of beautiful, natural, underground ice formations. Due to chemical reactions and water erosion those first fissures enlarged more and more over millions of years until they met each other under the mountains, creating this beautiful maze. Even to this day; these caves are in a continuous state of development, even though most of them are developing quite slowly due to the fact that now there is less water in the area than there was one million years ago.

It is recommended that you visit this ice giant on sunny and hot days, when the contrasts created make your visit all the more impressive. The panoramic view of the Salzach Valley is very impressive standing at the entrance.

Temple neuf de Metz—Metz, France

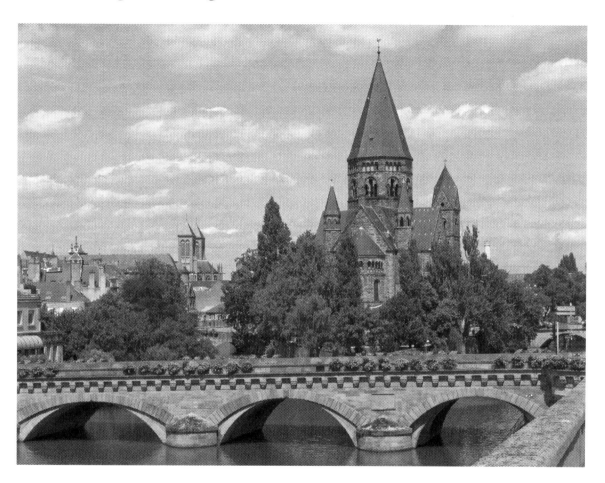

The New Temple and the German church is a building constructed in Metz during the German annexation. It demonstrates the policy of Germanization by the architecture deployed at that time by William II to consolidate his grip on the city. It is now the gathering place of the Protestant Reformed center of Metz. The municipality of Metz in 1889 granted to the Reformed community land called the Garden of Love, planted willows on the island of Little Saulcy for the erection of a temple in Rhenish Romanesque style.

The construction of the building began in 1901 and it was inaugurated in 1904 by Emperor Wilhelm II in person accompanied by the Empress, Princess Victoria Louise of Prussia and of the highest authorities of the Alsace Reichsland Lorraine. With this construction Wilhelm tried to present similar construction as other buildings in Metz, Lorraine with the German rule in stone. The Catholic Cathedral of Metz; in its French Gothic style, is often compared with Prussian Protestant construction, which is consistent with many of the true old German traditions.

Venice Skyline at Dusk—Venice, Italy

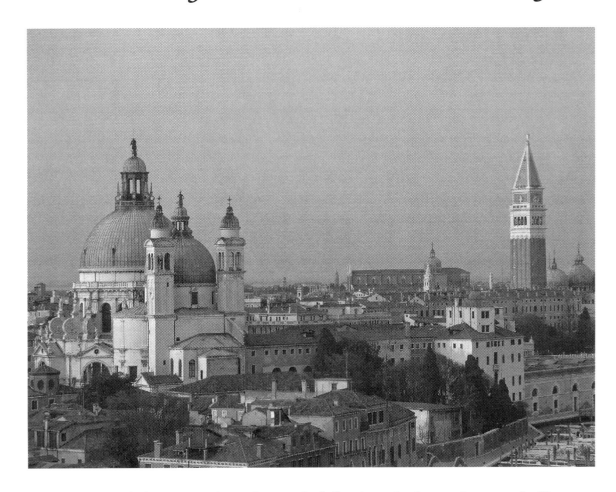

Venice captured the impression of a magical floating city by setting wood pilings on the 118 submerged islands in the Northern end of the Adriatic Sea. 400 foot bridges and 170 boat canals connect the city to make it easily accessible to the local populace. Venice can be compared to one big adventure. Once you are caught in the winding and seemingly endless streets and bridges of confusion, you would have no other choice but to keep on walking; which is actually a good thing! There's no better way to explore Venice than getting lost and be surprised in what it has to offer at your every turn.

Breaking away from the sea of tourists flocking at the city center in Piazza San Marco and heading for the narrowest alleyways is the greatest way to discover Venice! Taking a trip to Venice and failing to ride a Gondola is like going to France and ignoring the Eiffel tower. These traditional and symbolic boats have been used as transport around the narrow Venetian waterways for centuries.

Trulli Houses—Alberobello, Italy

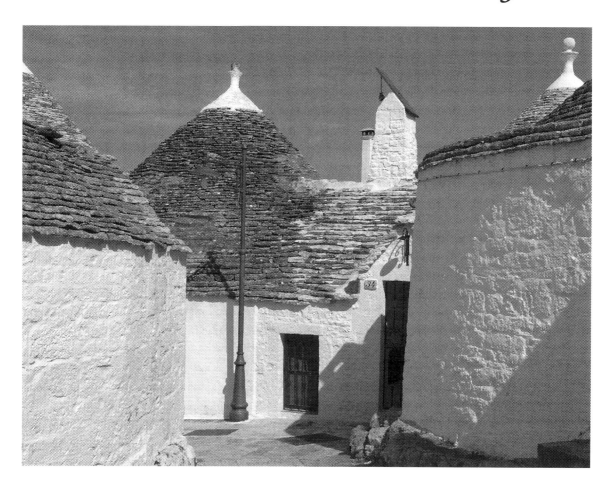

According to tradition; in 1620 the Trulli houses became urban residences. For the first time, Alberobello experienced a serious population increase. In those years; in fact, the Aragonese family issued the edict "Prammatica de Baronibus" which forbid the creation of new urban areas without the King's permission. The Earl skillfully got round the law and the farmers were forbidden to use any mortar for the construction of their "casedde", the Trulli houses. If the King decided to carry out an inspection, the farmers were ready to destroy the Trulli. A rope would have been tied to the top of the roof on the "pinnacle"; a horse would have pulled the rope, thus destroying the whole construction. Soon afterwards a new Trulli house would have been built on the same spot.

The Trulli house is made of small stones and is built with the dry-stone technique; its conical pyramid roof gives the building a particular original aspect that can only be admired in the Valley of Itria. In fact, these Trulli houses feature an architectural conception and a shape which are unique of their kind.

WWI Memorial—Verdun, France

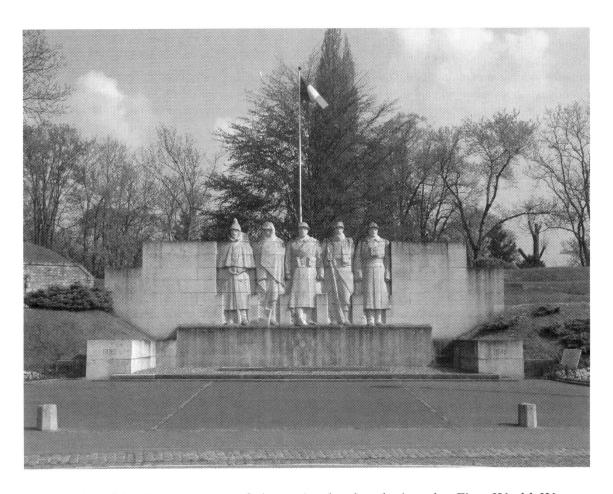

The Battle of Verdun was one of the major battles during the First World War on the Western Front. It was fought between the German and French armies, from 21 February to 18 December 1916, on hilly terrain north of the city of Verdun-sur-Meuse in north-eastern France. The Battle of Verdun ended as a French tactical victory. However; it can also be considered a costly strategic stalemate. The German High Command had failed to achieve its two objectives; to capture the city of Verdun and to inflict a much higher casualty count on its French adversary. By the end of the battle in December 1916, the French Second Army had rolled back the German forces around Verdun, but not quite to their initial positions of February 1916.

Verdun resulted in 306,000 battlefield deaths (163,000 French and 143,000 German combatants) plus at least half a million wounded personnel, an average of 30,000 deaths each of the ten months of the battle. It was the longest and one of the most devastating battles in the First World War and in current history.

Burg Ebernburg—Ebernburg, Germany

The castle Ebernburg gives the district Ebernburg the town of Bad Munster am Stein-Ebernburg in the Nahe region in Rhineland-Palatinate his name. It is located on the southeastern outskirts of the village on a promontory above the Nahe Valley. The first castle and a settlement may have been located originally in a different place, namely in the area around the Old John Evangelical Church (fortified church) in Ebernburg. First mention of the current Boar's castle dates back to 1206. In the years leading up to 1523; the castle was burned, re-built in 1542, 1697 and again in 1849. According to legend, many battles were fought in the Middle Ages around and within the Ebernburg Castle grounds. The castle residents should have starved but according to legend; however, when the supplies were scarce, the Lord would pull a boar into the yard and throw him on his back as if he were slaughtered. Of course, the boar roared every time in fear of death. When the besiegers heard this, they went off again, because they thought it would be enough food available for everyone. Why is the castle—the legend—now Ebernburg?

German Gate—Metz, France

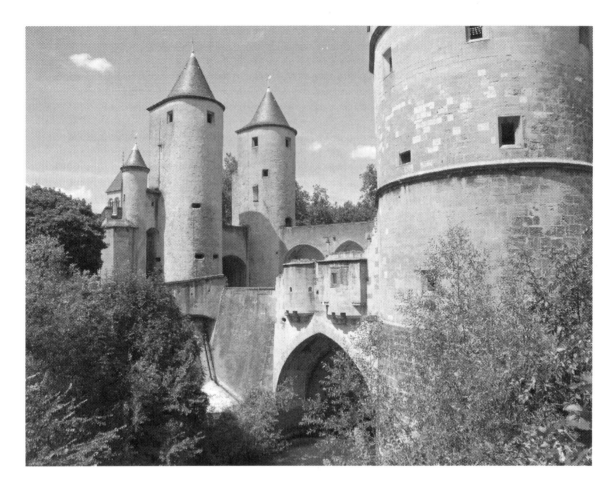

The impressive "Porte des Allemands" (German Gate) is one of Metz' most outstanding monuments. Even if it looks like a medieval fortress from afar, it is technically a fortified double gate that once was part of the extensive ramparts around Metz. The gate used to guard the eastern entrances of the city that came from the direction of Germany. The view of the whole structure standing on both sides of the Seille River is seen best from the bridge. The first gate on the town side was erected in the 13th century and features two towers surmounted with slate pepper-pot roofs.

The second gate was added in 1445 and is flanked by two large crenellated towers. It is possible to walk through the gate and to admire the military architecture of the medieval era, keeping in mind that the double gate underwent heavy restoration in the 19th century when the city was German! You can continue to stroll along the Seille River and follow the path on the town-side of the city where you can see the amazingly well preserved fortified medieval wall.

Crupet Castle—Crupet, Belgium

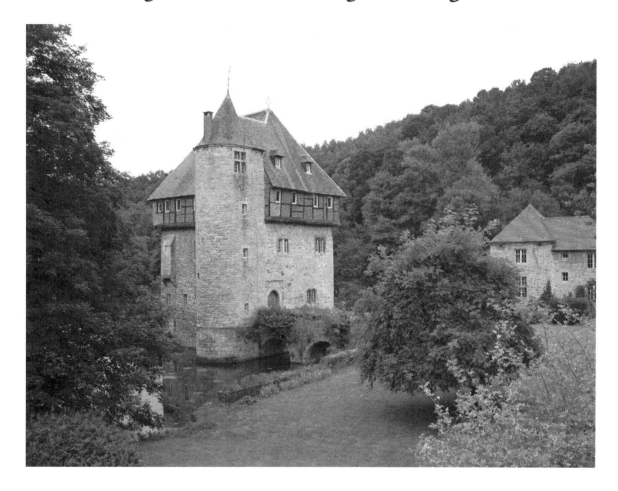

This beautiful square-shaped castle dates originally from the 13th century and is dominated by an impressive donjon. The storey under the roof is a valuable timber-framed construction. Crupet is a village in Wallonia, Belgium. It is part of the municipality of Assesse, although formerly it was itself a municipality. It is a member of the organization Les Plus Beaux Villages de Wallonie (French; in English: Most Beautiful Villages in Wallonia).

The center of the village is dominated by the Grotto of St Anthony of Padua. The grotto was designed by the local curate Gerard and inaugurated on 12 July 1903. It features 22 religious-themed statues. Many of them depict scenes from the life of St Anthony of Padua.

The Castle of Crupet is a medieval farm-chateau and is situated below the village center, and a little to the north, next to the river. It's an enchanted destination.

Chateau Villemenant—Guerigny, France

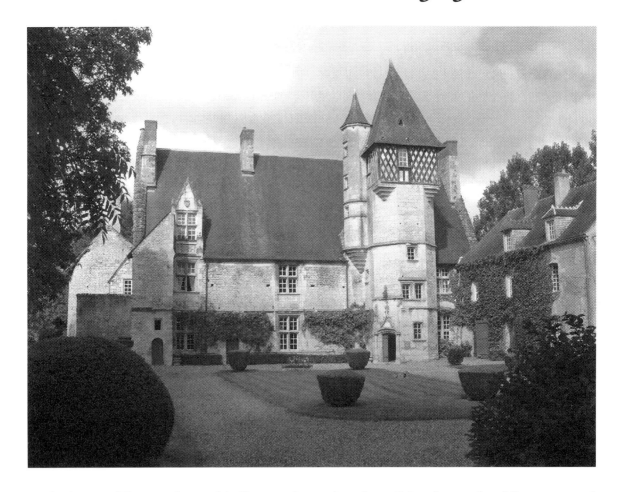

In the heart of France, located in Burgundy on the edge of the vineyards of Sancerre and Pouilly and near the ducal city of Nevers and the Monastic City Clunisienne of Charite sur Loire is where this Chateau is located. Visiting the wealth of the surrounding region, while living in a dream location is not so common.

Hidden in the bend of a path of stones and erected like a gem; Villemenant surprises the visitor. It was built in the mid-fourteenth century and restored at the dawn of the Renaissance. A family home; it combines the nobility of the middle Ages and the Renaissance charm with modern comfort. Villemenant is the ideal place to impress yourself and others and is family friendly.

On the banks of the Nièvre, its quiet and greenery is conducive to the party and at work, at leisure to thinking and walking.

Chateau du Lac—Orval, Luxembourg

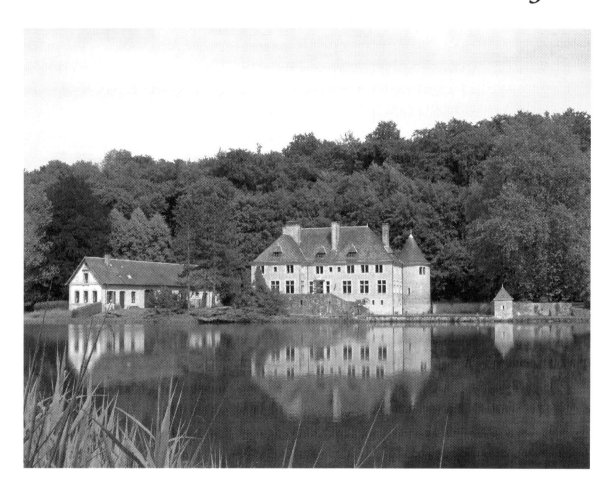

Chateau du Lac is a beautiful dwelling only 100 meters from Orval Abbey. Orval Abbey is a Cistercian monastery founded in 1132 in the Gaume region of Belgium and is located in Villers-devant-Orval, part of Florenville in the province of Luxembourg. The abbey is well-known for its history and spiritual life but also for its local production of a Trappist beer (see Brasserie d'Orval) and a specific cheese. The site has been occupied since the Merovingian period, and there is evidence that there was already a chapel here in the 10th century.

Around 1252, the monastery was destroyed by a fire; the rebuilding took around 100 years. In the literary field the monks of Orval didn't much distinguish themselves. During the 15th and 16th centuries, the various wars between France and various neighboring regions (Burgundy, Spain) had an important impact on Orval. In 1793, during the French Revolution, the abbey was completely burnt down by French forces, in retaliation for the hospitality it had provided to Austrian troops and the community dispersed.

Colorful Bench—Garmisch, Germany

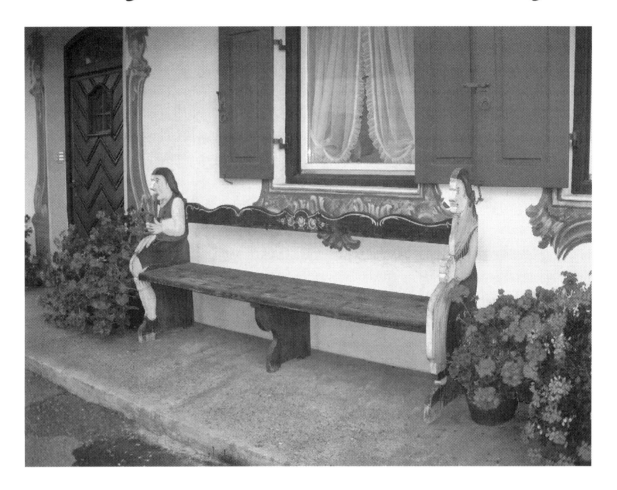

Amazing sights as you stroll around Garmisch-Partenkirchen are the figures carved on wooden benches on the decorative house fronts. Vacationers to Bavaria had undoubtedly heard of "Garmisch", more properly known as Garmisch-Partenkirchen, a dual-town at the base of the Bavarian Alps.

It is one of the most popular resort spots for Germans, Austrians, and other nationalities due to its convenient location and year-round offering of things to do. It is especially popular among Americans, who since the end of World War II have had their own resort facilities in the area that caters to the rest and recreation needs of American military members. Several dozen hotels, guesthouses, and restaurants lay in close proximity with some able to host large events for hundreds of people. It is also one of the friendliest towns around, one of those special places that keep visitors talking long after their visit. It is the year-round nature of Garmisch-Partenkirchen that has made it so successful—skiing throughout the winter, hiking and countless places to visit in the summer.

Zugspitze—Grainau, Germany

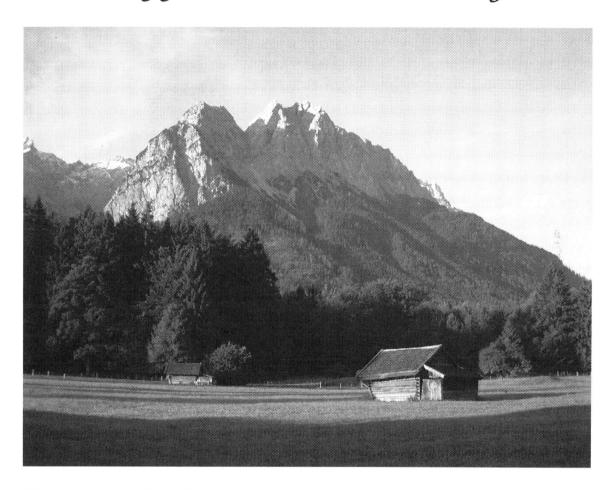

The Zugspitze is the highest mountain in Germany, at 2,962 meters above sea level. It is located on the Austrian border beside the town of Grainau in the district of Garmisch-Partenkirchen, in the federal-state of Bavaria. On the Austrian side lies the town of Ehrwald in the district of Reutte, Tyrol. There is a cog railway (the Bavarian Zugspitze Railway) leading from the tourist resort of Garmisch-Partenkirchen to the Zugspitzplatt from where a cable car runs to the peak. There are also two cable cars that go to the peak from the base of the mountain: one ascends from the German side of the mountain at the lake Eibsee (Eibsee Cable Car), and the other ascends from Austria near Ehrwald (Tyrolean Zugspitze Cable Car). The peak is regularly crowded with tourists.

The Zugspitze belongs to the Wetterstein range in the Northern Limestone Alps. It gets its name from the many avalanche passages (Lawinenzüge in German) on its steep north slopes. The border between Germany and Austria goes right through the mountain. There used to be a border checkpoint at the summit.

Crows on the Rail—Mount Titlis, Switzerland

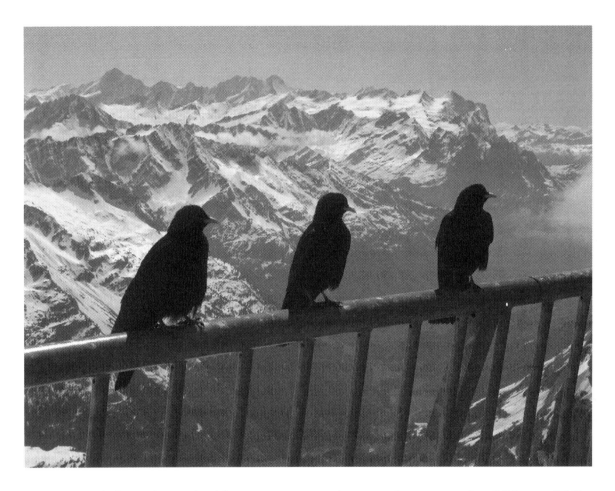

The shot of these funny looking crows was taken on the top peak of Mount Titlis. The Titlis (3,238 m) is a mountain in the Urner Alps of Switzerland. It is located on the border between the cantons of Obwalden and Berne in Switzerland, overlooking Engelberg (Obwalden) and is famous as the site of the world's first revolving cable car. The cable car system connects Engelberg to the summit of Klein Titlis (3,028 m) through the three stages of Gerschnialp (1,262 m), Trübsee (1,796 m) and Stand (2,428 m). The Titlis is located between the municipalities of Engelberg on the north and Gadmen on the south.

The Titlis is the highest mountain in the portion of the Urner Alps north of the Susten Pass. This part of the range is located between the valleys of the Hasli (west) and the Reuss (east), thus separating the waters feeding the basins of the Aar and Reuss respectively. On the north side the valley of Engelberg (Engelbergertal) is drained by the Engelberger, a tributary of the Reuss. The valley is located southwards from the beautiful pristine Lake Lucerne.

WWII American Cemetery, Omaha Beach—Normandy Beach, France

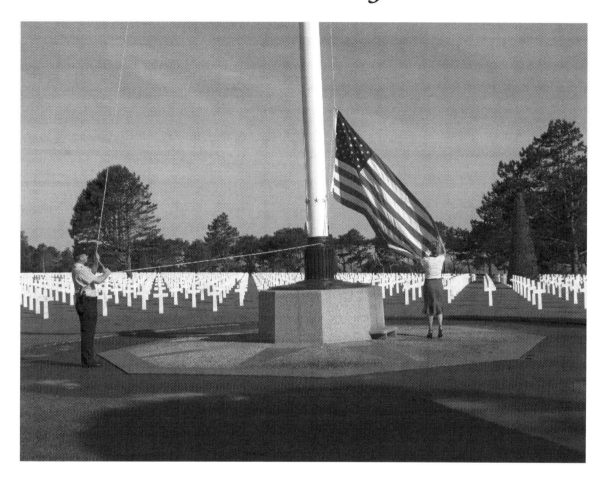

The Normandy American Cemetery and Memorial is a World War II cemetery and memorial in Colleville-sur-Mer, Normandy, France, that honors American soldiers who died in Europe during World War II. On June 8, 1944, the U.S. First Army established the temporary cemetery, the first American cemetery on European soil in World War II. After the war, the present-day cemetery was established a short distance to the East of the original site.

Like all other overseas American cemeteries in France for World War I and II, France has granted the United States a special, perpetual concession to the land occupied by the cemetery, free of any charge or any tax. This cemetery is managed by the American government, under Congressional acts that provide yearly financial support for maintaining them, with most military and civil personnel employed abroad. The U.S. flag is lifted every morning and flies over these granted soils 365 days a year as a tribute to those who gave all for us.

Eiger and Monsch—(taken from) Piz Gloria, Switzerland

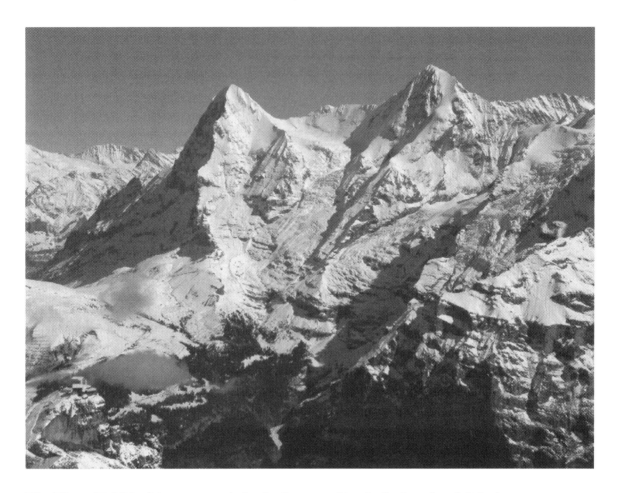

The Eiger (3,970m) is a mountain in the Bernese Alps in Switzerland. It is the easternmost peak of a ridge-crest that extends across the Mönch to the Jungfrau at 4,158 m. The northern side of the mountain rises about 3 km above Grindelwald and other inhabited valleys of the Bernese Oberland, and the southern side faces the deeply glaciated region of the Jungfrau-Aletsch, covered by some of the largest glaciers in the Alps.

The first ascent of the Eiger was made by Swiss guides Christian Almer and Peter Bohren and Irishman Charles Barrington, who climbed the west flank on 11 August 1858. Since 1935, at least sixty-four climbers have died attempting the north face, earning it the German nickname Mordwand, literally "Murder Wall". From the Kleine Scheidegg, a railway tunnel runs inside the Eiger and two internal stations provide easy access to viewing-windows in the mountainside.

Burg Meersburg (Bodensee)—Meersburg, Germany

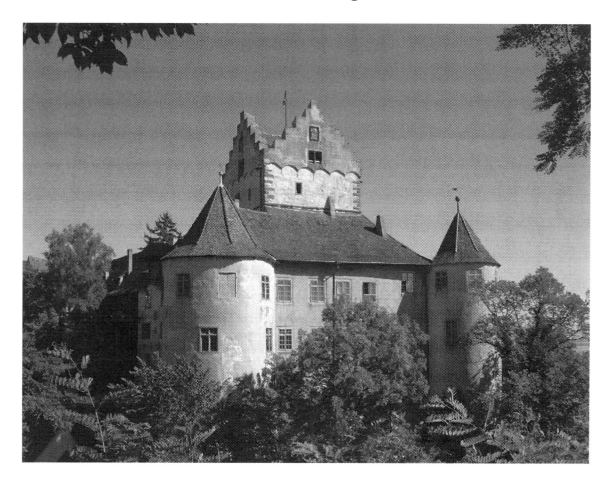

Meersburg is a town of Baden-Württemberg in the southwest of Germany at Lake Constance. It is famous for its charming medieval city. The lower town ("Unterstadt") and uptown ("Oberstadt") are reserved for pedestrians only and connected by two stairways and a steep street ("Steigstrasse"). The name of the town means "Burg on the Lake", the former referring to the castle. The castle was built here in 630 by the Merovingian King Dagobert the 1st.

The commune obtained the status of free city in 1299, though nominally still under the Bishop of Constance. In 1803 it was annexed to the Land of Baden. After World War II, Meersburg remained in the French military occupation area in Germany. The town is home to two castles, the Old Castle (pictured) and was also the home of the German poetess Annette von Droste-Hülshoff. The castle is visible from many angles as you approach Meersburg from the lake.

Schloss Hohenwerfen—Werfen, Austria

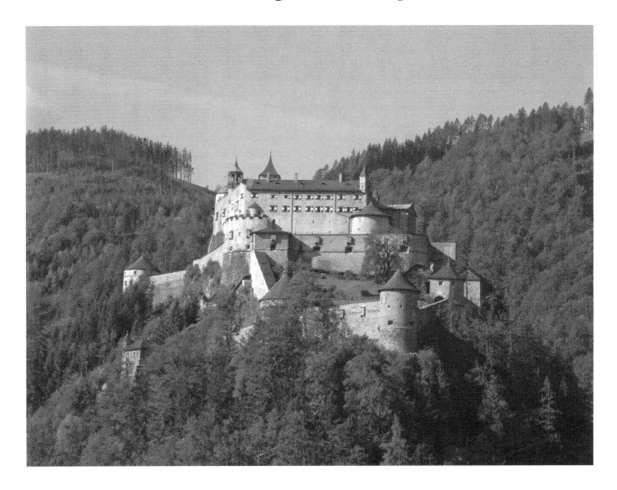

Hohenwerfen Castle (German: Burg Hohenwerfen) stands on a rock approximately 40 km south of the Austrian city of Salzburg. The castle is majestically surrounded by the Berchtesgaden Alps and the Tennengebirge mountain range. The fortification is a "sister" of Hohensalzburg Castle both dated from the 11th century. The former fortification was built between 1075 and 1078 during the Investiture Controversy by the order of Archbishop Gebhard of Salzburg as a strategic bulwark atop a 155 meter rock, high above the Salzach valley.

Gebhard was expelled in 1077 and could not return to Salzburg until 1086, only to die at Hohenwerfen two years later. Alternatively it was used as a state prison and therefore had a somewhat sinister reputation. Its prison walls have witnessed the tragic fate of many 'criminals' who spent their days there; maybe their last and under inhuman conditions. Periodically, various highly ranked noblemen have also been imprisoned there including many local rulers.

St Paul's Bay Church—Lindos Acropolis—
Rhodes, Greece

At the foot of the Acropolis is St Paul's Bay. The white chapel is dedicated to Saint Paul who landed here in 43 AD to preach Christianity. Saint Paul's Bay is the second magnificent beach of Lindos, and a very popular wedding location because of the beautiful views of St Paul's beach and Lindos Acropolis! Saint Paul's Bay located in Lindos, Rhodes is a small rocky bay about one quarter mile square just south of Lindos town.

It's about 250 yards or three minutes walk from the Kyriakos apartments. The bay is a great place for snorkeling and is relatively shallow at about 20 feet deep. It is possible to dive off adjacent rocks with care, and you do need to be on the lookout for snorkelers and the glass bottom boat which occasionally enters the bay. The two beaches; one with a mix of natural sand and gravel and the other with a manmade beach of golden sand are relatively un-crowded and relaxed.

Meuse-Argonne WWI American Cemetery—Argonne, France

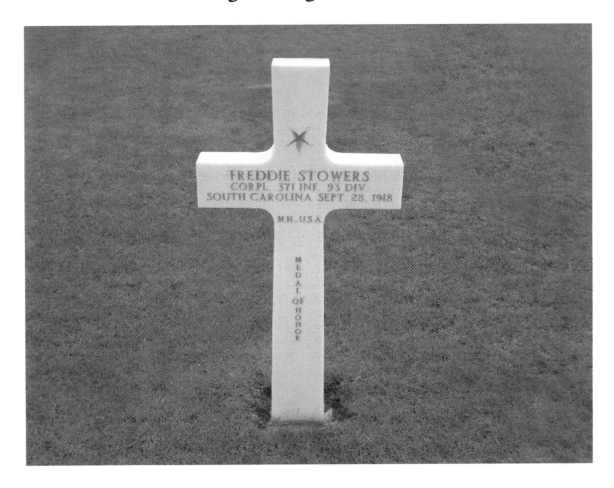

The Meuse-Argonne American Cemetery and Memorial is a 130 acre World War I cemetery in France. It is located east of the village of Romagne-sous-Montfaucon in Meuse. The cemetery contains the largest number of American military dead in Europe (14,246); most of who lost their lives during the Meuse-Argonne Offensive are buried there. Two such notable burials are Medal of Honor winners Corporal Freddie Stowers (posthumously awarded the Medal of Honor 73 years after his death in action).

The cemetery consists of 8 sections behind a large central reflection pool. Beyond the grave sections is a chapel which is decorated with stained glass windows depicting American units' insignias. Along the walls of the chapel area are the tablets of the missing which include the names of those soldiers who fought in the region and in northern Russia, but have no known grave.

Horse Parade Royal Guard—London, England

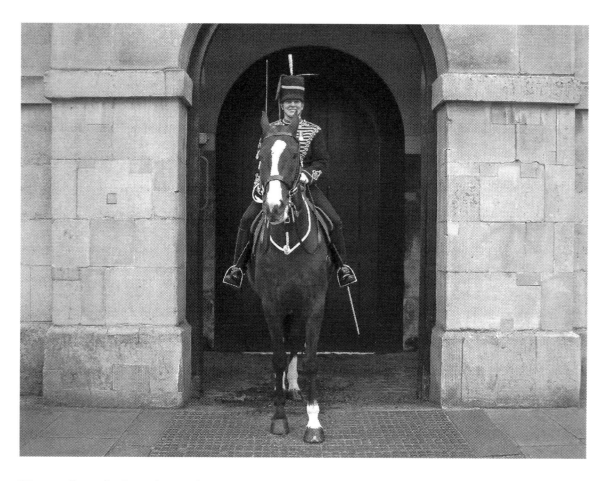

Horse Guards Parade is the setting for various military ceremonies throughout the year including the Trooping the Color which marks the Queen's official birthday. At the heart of Whitehall, it was the traditional entrance to the Royal Palaces and is still guarded by mounted sentries from the Queen's Household Cavalry. Horse Guards Parade was formerly the site of the Palace of Whitehall's tiltyard, where tournaments were held in the time of Henry VIII. It was also the scene of annual celebrations of the birthday of Queen Elizabeth I.

The area has been used for a variety of reviews, parades and other ceremonies since the 17th century. It was once the Headquarters of the British Army. The Duke of Wellington was based in Horse Guards when he was Commander-in-Chief of the British Army. The parade ground is open on the west side, where it faces the Horse Guard's Road and St. James's Park.

Predjamski Grad—Predjama, Slovenia

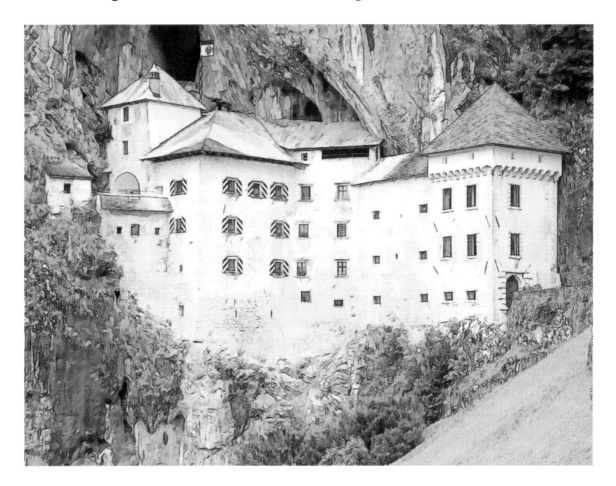

Predjama Castle (Slovene: Predjamski grad or Grad Predjama, German: Höhlenburg Lueg, Italian: Castel Lueghi) is a Renaissance castle built within a cave mouth in southwestern Slovenia. It is located approximately 11 kilometers from Postojna. The castle was first mentioned in the year 1274 with the German name Luegg, when the Patriarch of Aquileia built the castle in Gothic style. The castle was built under a natural rocky arch high in the stone wall to make access to it difficult. It was later acquired and expanded by the Luegg noble family, also known as the Knights of Adelsberg (the German name of Postojna).

The castle became known as the seat of Knight Erazem Lueger (or Luegger), owner of the castle in 15th century and a renowned robber baron. He was the son of the Imperial Governor of Trieste, Nikolaj Lueger. Erazem came into conflict with the Habsburg establishment, when he killed the commander of the Imperial army Marshall Pappencheim. Fleeing from the revenge of the Holy Roman Emperor Frederick III, Erazem settled in the family fortress of Predjama.

Old Town Hall—Annecy, France

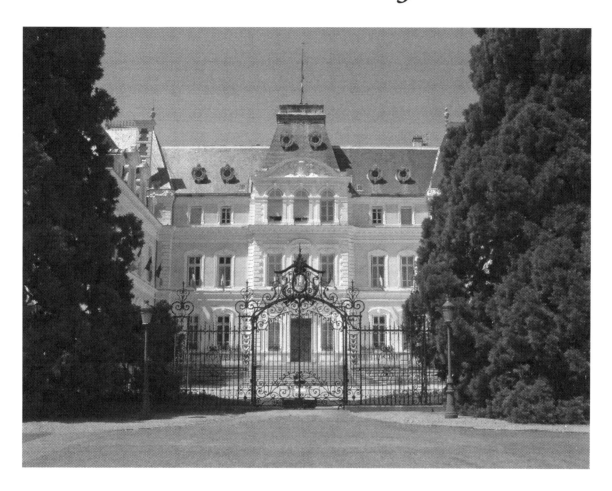

Annecy is situated between Geneva and Chambery on the shores of the beautiful Lake Annecy. It occupies a strategic location on routes between Italy, Switzerland and France. The city is crossed by the Thiou River, which gives the city a Venetian ambiance. Annecy has a really long history and some of the recent archaeological digs date the coastal village near Annecy-le-vieux at 3100 years BC. Between the 10th and the 19th century, the city was strongly influenced by the destiny of Geneva and Chambery. Finally, Annecy knew its last government change in 1860, with the annexation of Savoy to France and became the capital of the new department (subdivision of the country) of Haute-Savoie.

Today; Annecy is a city loaded with history that you can discover by walking through the cobble-stone streets around town. The city offers some activities for everybody: discover some traditional shops, taste some fish from the Thiou in one of the several restaurants, visit the castle or one of the numerous churches or go for a cruise on the lake.

Schloss Loppem—Loppem, Belgium

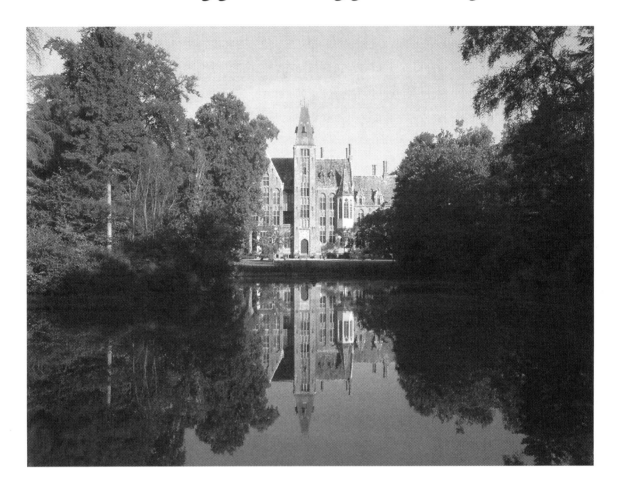

This Gothic Revival mansion in Belgium designed by Edward Welby Pugin retains its original architecture and interior, and lies in a park, with ponds and a labyrinth. Loppem Castle (Dutch: Kasteel van Loppem) is a castle situated in Loppem in the municipality of Zedelgem, near Bruges in West Flanders, in the Flemish Region of Belgium. It was built between 1859 and 1862 for Baron Charles van Caloen and his family to designs by E.W. Pugin and Jean-Baptiste de Béthune and is considered a masterpiece of civil Gothic Revival architecture.

Although it's not the only castle in Belgium to have preserved its amazing original architecture and interior decoration, it has been remarkably well preserved since the 19th-century. The castle has a richly decorated and furnished interior and houses a collection of works of art (paintings, stained glass and statuary). The castle is surrounded by a romantic park with ponds and a maze. The castle and park are owned by the Stichting Jean van Caloen Foundation and are open to the public.

Burg Eltz—Munstermaifeld, Germany

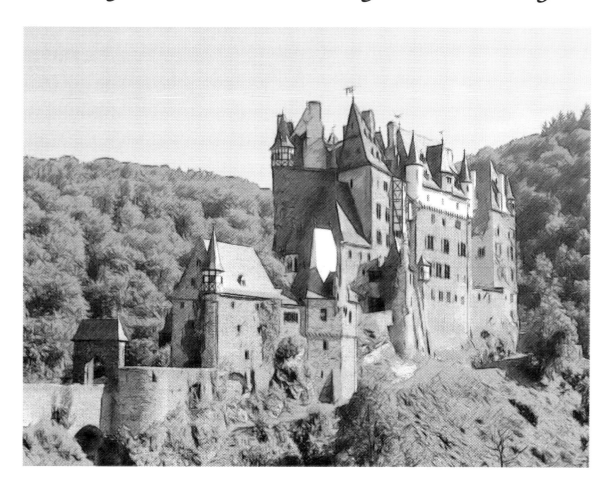

Burg Eltz is a medieval castle nestled in the hills above the Mosel River between Koblenz and Trier, Germany. It is still owned by a branch of the same family that lived there in the 12th century, 33 generations ago. The Rübenach and Rodendorf families' homes in the castle are open to the public, while the Kempenich branch of the family uses the other third of the castle. The castle is surrounded on three sides by the Elzbach River, a tributary on the north side of the Moselle. It is situated on a 70m rock spur, on an important Roman trade route between rich farmlands and their markets.

The castle is a so-called Ganerbenburg, or castle belonging to a community of joint heirs. This is a castle divided into several parts, which belong to different families or different branches of a family; this usually occurs when multiple owners of one or more territories jointly build a castle to house themselves. Only a very rich medieval European lord could afford to build a castle on his land; many of them only owned one village, or even only a part of a village.

Schloss Reichenstein—Rhine River, Germany

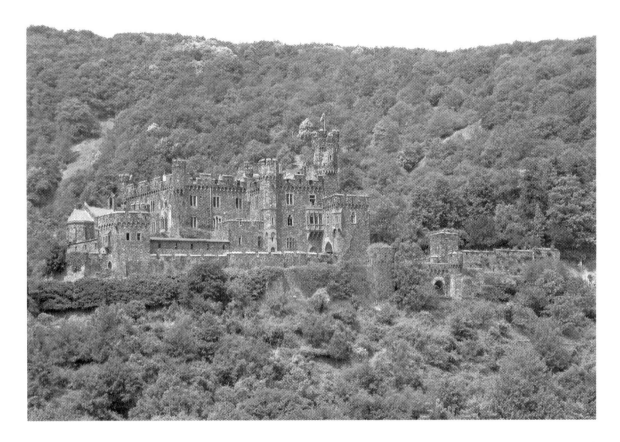

Schloss Reichenstein is truly atmospheric, with dark stone walls, narrow windows and crenellated battlements that bring its turbulent history vividly to life. It was initially built to protect the village (now the city of Aachen) from invasion in the early eleventh century and the local abbey appointed a castellan baron to manage it. Towards the end of the following century, several generations of barons who lived at the castle began to impose illegal tolls on ships and carriages in the Rhine area, and engaged in a reign of terror until they were deposed in 1253 by the Rhine League, and the castle was destroyed. However, several successive groups of feudal barons kept up this practice and the castle was destroyed and rebuilt on numerous occasions, in different styles.

The final rebuilding began in 1899 and was instigated by Baron Kirsch-Puricelli, who took ownership of it and restored it as faithfully as possible with the use of its original plans, incorporating a great deal of neo-gothic artistry. It now functions as an impressive, medieval-style hotel and restaurant to guests.

Josip Broz Tito's Summer Residence— Bled, Slovenia

A settlement area since Mesolithic times, Bled Castle was first mentioned as Ueldes (Veldes) within the March of Carniola on April 10, 1004, when it was awarded by Emperor Henry II to Bishop Albuin I of Brixen. With Carniola, it was ceded to Rudolph of Habsburg after he defeated King Ottokar II of Bohemia at the Battle on the Marchfeld in 1278. From 1364 until 1919, Bled (Veldes) was part of the Duchy of Carniola, except for a stint between 1809 and 1816 as one of the Napoleonic Illyrian Provinces

After the dissolution of Austria-Hungary in 1918, Bled came under the rule of the Kingdom of Yugoslavia and became a summer domicile of the ruling House of Karadordevic, a tradition that President Josip Broz Tito continued, when he built his residence here in 1947. Bled became an independent municipality in 1996. In 2000, Bled became the home of IEDC-Bled School of Management.

Corroy-le-Chateau—Gembloux, Belgium

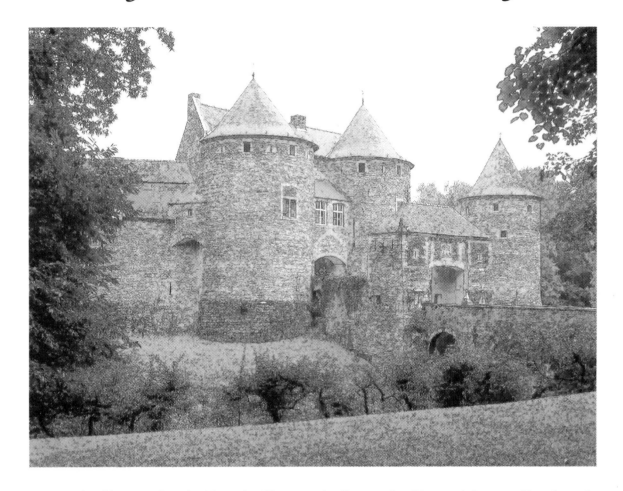

Corroy-le-Chateau Castle (French: Chateau de Corroy-le-Chateau) is a medieval castle in the village of Corroy-le-Chateau and the municipality of Gembloux in the province of Namur, Belgium. Gembloux is a Walloon municipality located in the Belgian province of Namur, on the axis Brussels-Namur. Originally built between 1220 and 1230 by William of Brabant, the castle is one of the best-preserved medieval castles in Belgium, with gigantic round towers and a moat. A moat is a deep, broad ditch, either dry or filled with water that surrounds a castle. In some places moats evolved into more extensive water defenses, including natural or artificial lakes, dams and sluices. In later castles; the moat or water defenses may be largely ornamental.

After some eight hundred years in the possession of the descendants of William of Brabant, the last of whom to live there was the Marquis de Trazegnies, a family dispute led to a court ordering the sale of the castle at public auction. The castle is privately owned today but can be visited when arrangements are made.

Saint Mihiel WWI American Cemetery—Saint Mihiel, France

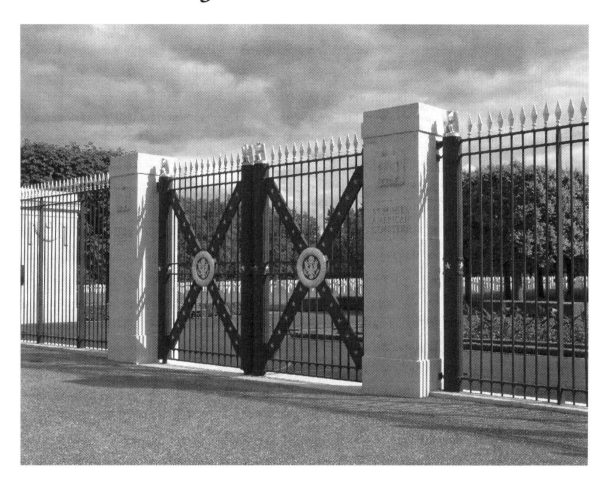

The St. Mihiel American Cemetery and Memorial in France, 40 acres in extent, contains the graves of 4,153 of American military dead from World War I. The majority of these died in the offensive that resulted in the reduction of the St. Mihiel salient that threatened Paris. The burial area is divided by Linden alignment trees and paths into four equal plots. At the center is a large sundial surmounted by an American eagle.

Beyond the burial area to the south is the white stone memorial consisting of a small chapel. The chapel contains a beautiful mosaic portraying an angel sheathing his sword. On two walls of the museum are recorded the names of 284 of the missing. Rosettes mark the names of those since recovered and identified. On the wall facing the door is a large map of inlaid marble depicting the St. Mihiel WWI military offensive.

Altfinstermünz Bridge—Nauders, Switzerland

Thrillingly sinister—the geographical position of the valley dam Finstermünz (Austria) in the gorge-like valley-bottom of the Inn, approximately 10 km distant from Samnaun has been from time immemorial a very important road connection between Landeck into the Vinschgau and the Engadin. Over the centuries this has been one of the most significant and profitable frontier and customs crossing from the south to the north.

In 1770, as a consequence of the customs reforms, Finstermünz lost its importance and Alfinstermünz then simply housed a roadside tavern. In 1854 a newly constructed road from Pfunds to Nauders marked a further decline in its use and significance. The project partners have as their goal the wish to re-open the historical mountain pass hermitage for those interested visitors. With the creation of a 'Historical Experience World, Altfinstermünz' one aims to attract the interest of a wider group of people than merely the circle of those historically interested.

Burg Reifenstein—Sterzing, Italy

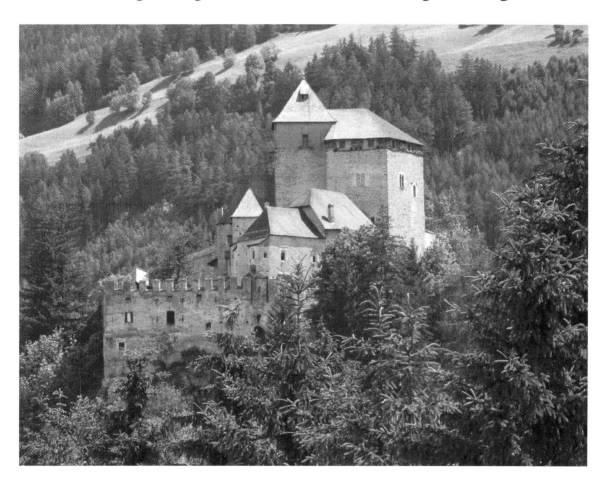

One hour south of Innsbruck at the Italian town of Vipiteno (called "Sterzing" by residents who prefer German) is the Reifenstein Castle. With her time-pocked sister just opposite, Reifenstein bottled up this strategic valley leading to the easiest way to cross the Alps.

Reifenstein offers castle connoisseurs the best-preserved original medieval castle interior I've ever seen. The lady who calls the castle home, Frau Blanc, takes groups through in Italian and in German. You'll discover the mossy past as she explains how the cistern collected water, how drunken lords managed to get their keys into the keyholes, and how prisoners were left to rot in the dungeon (you'll look down the typical only-way-out hole in the ceiling). In the only surviving original 'knights' sleeping quarters, you'll see how knights spent their nights. The amazing little fortified town of Glurns hunkers down about an hour west of Reifenstein Castle. Glurns still live within its square wall on the Adige River, with a church bell tower that has a thing about ringing out of sequence.

Burg Gutenberg—Balzers, Liechtenstein

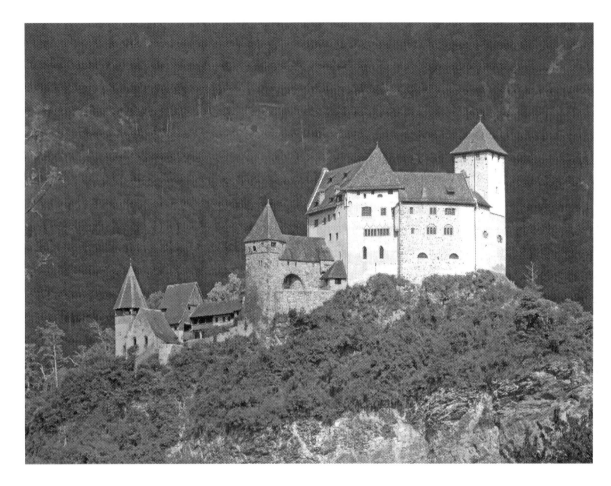

Balzers, the southernmost municipality of Liechtenstein, comprises the settlements of Balzers and Mäls. Since the Second World War, the municipality of Balzers has undergone a decisive structural transformation, in which the areas of industry, trade, and services in particular have developed considerably.

Gutenberg Castle was first mentioned in writing in 1263; it was presumably built in the 11th century. It belonged to the barons of Frauenberg in 1305. It was transferred to the dukes of Austria in 1314 and remained in Austrian possession for more than 500 years. In 1750, it was left to decay. The municipality of Balzers bought the decaying castle with its property in 1824. In 1905, the sculptor Egon Rheinberger from Vaduz purchased the ruins and expanded the castle into its current form between 1906 and 1910 according to his own plans. For several years, a restaurant was run in the castle. Today, the castle belongs to the State. It has been restored in recent years, so that the interior and exterior spaces have been used since August 2000 for cultural and social events.

Musee Departmental Albert Demard—Champlitte, France

Berger, tannery worker, poor grower, Albert Demard is struck by the fever of Malta. Peasant self-taught; he took the opportunity to study. Very quickly, he understands the need to save the traces of a disappearing world. In the attic of the Chateau de Champlitte (Haute-Saone) which he is the janitor, he set up his first museum of farming life in 1952. The idea of establishing this museum brings together three institutions Demard envisioned and created.

Former farmer, he witnessed the modernization of farms at the turn of the fifties and decides to seek different things from the farmers in 1956 to form the first museum; the Museum of Folk Art and Museum 1900-arts and technical Museum of Presses.

With time and support of Georges-Henri Riviere, an official museum started taking shape (1957). In 1963, it became the county museum where Albert Demard became the first curator. He died in 1980.

Chateau Aertrycke—Torhout, Belgium

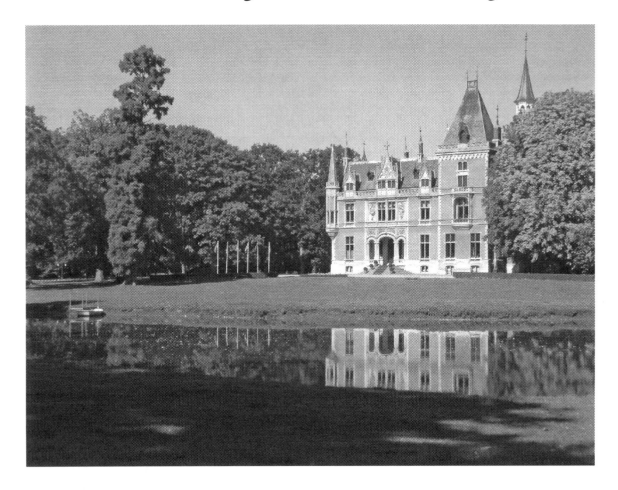

Located in the grounds is the historical Kasteel d'Aertrycke, the Hotel D'Aertrycke is situated in 104 acres of beautiful countryside and surrounded by gardens, woods and lakes. Visitors love the peacefulness and serenity of the picturesque location. There are numerous walking and cycling paths in the vicinity; the perfect way to explore the surroundings. The historical and special city of Bruges is a short twenty minutes drive from the scenic Belgium coast.

The division of Commons has put this prestigious residence on the entity and its Torhout Wijnendaele part of which has thus two castles. The village of Aartrijke is located on the other side of Zedelgem. The castle is placed at the heart of the park in a slight overhang, as it overlooks a pond. Its north side is also reflected in a mirror of water, larger than the first mentioned. The house is one of the finest creations of Joseph Schadde; an Antwerp architect of great repute who was responsible for public buildings in the province of Antwerp and where he restored the cathedral of the Metropole.

Schloss Karneid—Bolzano (Bozen), Italy

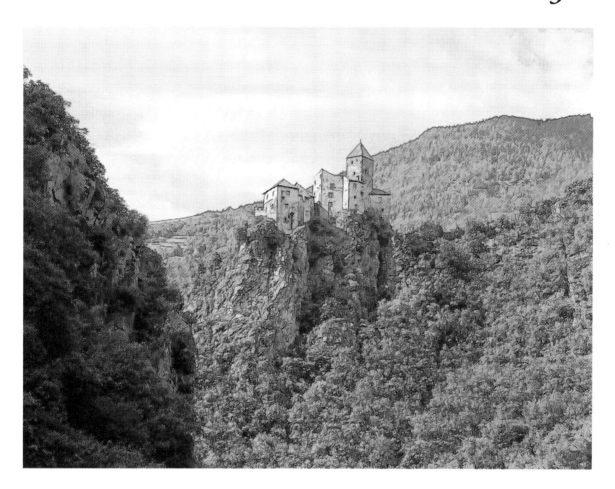

The origins of the castle Karneid go back to the year 1200; the foundation stones for this were laid by the noble family of Greifensteiner. In the 14th Century, the castle came into possession of the Lords of Vols, then the later Governor Henry Gessler and finally to the Counts Lichtenstein.

The castle has been altered over the centuries. There were different add-ons and additions such as the western gate tower and the last building (1573), the eastern tower of the kennel through which the original main entrance was moved to the castle from west to east. Apart from a few little things; the original form of the 16th Century Castle, until today has remained unchanged. The interior of the fort offers a wealth of beautiful art and cultural history of highly interesting details. The St. Anna consecrated Chapel has particularly valuable Romanesque frescoes. Karneid borders Bolzano (Bozen), Völs am Schlern (Fiè allo Sciliar), Welschnofen (Nova Levante), Deutschnofen (Nova Ponente), Ritten (Renon), and Tiers (Tires).

Cathedral de Palma, Palma de Mallorca

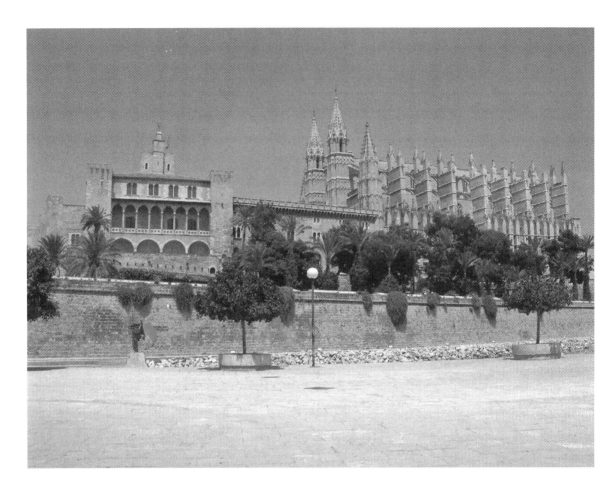

Any visitors approaching Palma by sea cannot help but be impressed and even astonished by the graceful Gothic cathedral as it gradually emerges into view. Its upward-reaching lines seem to rise endless as the boat gets nearer, until they merge into its protective shield of palm trees in front, the old quarter houses behind it, and the colorful fishing boats and their undulating reflection in the calm waters of the bay. The Seo, as it is called there, was built on the site of a pre-existing Arab mosque.

One night in 1229, as Jaime I was on his way to recapture Majorca, his fleet was struck by a terrible storm. He vowed to the Virgin Mary that if he survived nature's fury, he would erect a church in her honor. After the storm had blown over; finding himself safe and sound, he immediately undertook the project. It was a vow that was to take an inordinate amount of time to fulfill. Begun in 1230; the cathedral was finished in 1601. The rear interior reveals the majestic "Royal Chapel" with its main altar and enormous wrought-iron chandelier.

Valldemossa, Mallorca

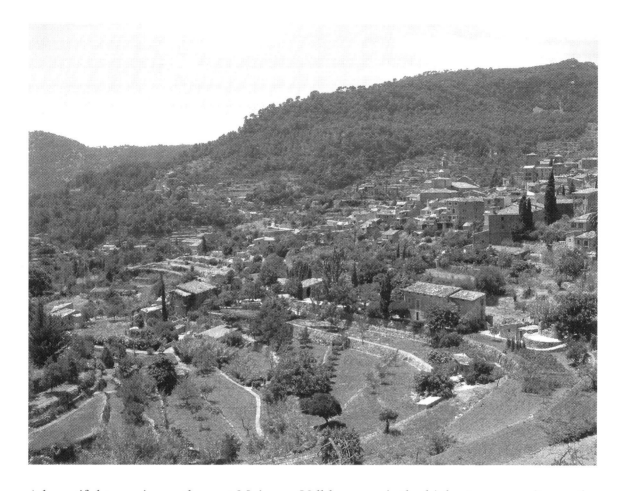

A beautiful town in north-west Majorca, Valldemossa is the highest community on the island and sits on the slopes of the Tramuntana Mountains. It has become increasingly geared towards tourists in recent years; but with its olive and almond trees, surrounds its steep streets and unexpected miradors which retains a genuine charm. The town gained some sort of fame when Polish composer Frederic Chopin came and stayed at the Carthusian monastery (Cartoixa Reial) with his lover George Sand in the winter of 1838-39. The monastery had been turned into rental accommodations three years earlier during the suppression of the monasteries where monks had lived since 1399.

Nowadays the monastery is the second most visited building on the island, after Palma Cathedral. You can see where Chopin and Sand lived for four months and admire his piano and some manuscripts. Elsewhere, the monastery church hosts the Municipal Museum, which has a small collection of modern art which can be visited by passers-by.

Little Venice—Colmar, France

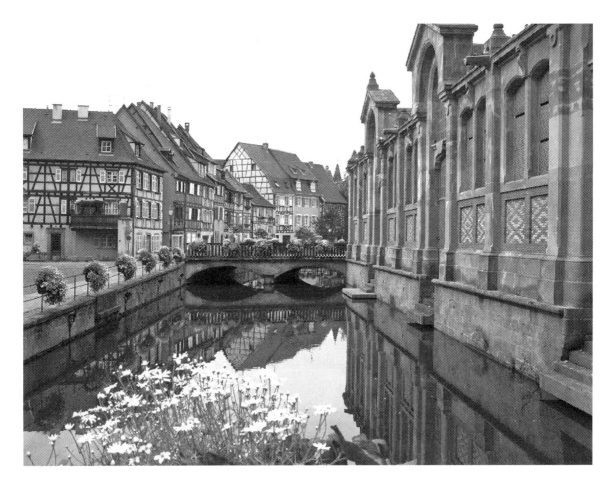

Colmar is a commune in the Haut-Rhine department in Alsace in north-eastern France. Colmar is also the seat of the highest jurisdiction in Alsace, the appellate court. It is situated along the Alsatian Wine Route and considers itself to be the "Capital of Alsatian Wine" (capitale des vins d'Alsace). Colmar is the home town of the painter and engraver Martin Schongauer and the sculptor Frederic Bartholdi, who designed the Statue of Liberty. The city is renowned for its well preserved old town, its numerous architectural landmarks and its museums among which is the Unterlinden Museum.

Colmar was founded in the 9th century. Colmar was granted the status of a free imperial city of the Holy Roman Empire in 1226. In 1575, the city adopted the Protestant Reformation, long after its northern neighbors of Strasbourg and Selestat. During the Thirty Years' War, the city was taken by the armies of Sweden in 1632, conquered by France in 1673, annexed by the newly formed German Empire in 1871 and returned to France after World War I.

Burg Linster—Bourglinster, Luxembourg

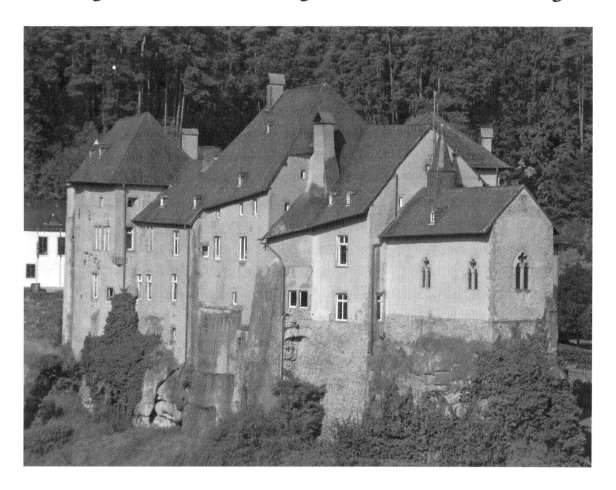

Bourglinster Castle, locally also known as Burg Linster, lies in the village by the same name, south west of the town of Junglinster in Luxembourg. Bourglinster castle was first mentioned in 1231. In the second half of the 14th century the castle was owned by the Lords of Orley. In 1421 the castle became a 'Ganerbenburg'; which meant that it was owned and lived in by several noble families. In this case the Orley, Hammerstein, Bettstein, Waldeck and Metzenhausen families. All the rules of this joint ownership were laid down in a 'Burgfrieden'; a Castle of Peace.

Bourglinster Castle was probably founded in the late 10th century. It consisted of an upper and lower castle. The lower castle was finished in the early 15th century. The moat was dug out in the 15th century, but did not protect the castle quite as was intended, because in 1682 and again in 1684 French troops attacked and destroyed parts of the castle. Almost all the buildings of the lower castle were demolished in the late 17th century; however. In 1850 the castle was restored.

Lorraine WWII American Cemetery—Saint Avold (Alsace Lorraine), France

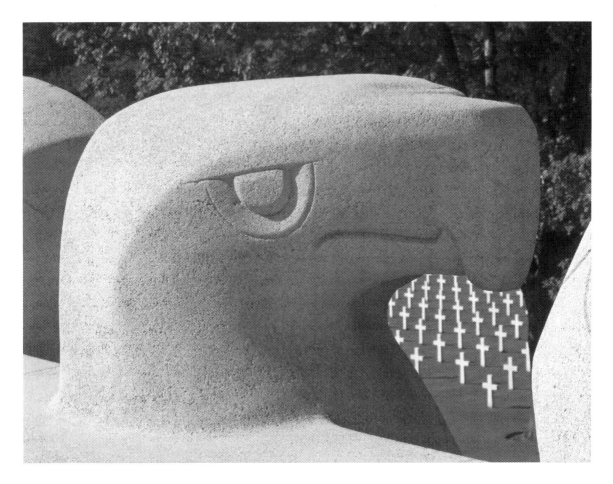

The Lorraine American Cemetery and Memorial in France covers 113.5 acres and contains the largest number of graves of our military dead of World War II in Europe, a total of 10,489. Their headstones are arranged in nine plots in a generally elliptical design extending over the beautiful rolling terrain of eastern Lorraine and culminating in a prominent overlook feature. Most of the dead here were killed while driving the German forces from the fortress city of Metz toward the Siegfried Line and the Rhine River. Initially, there were over 16,000 Americans interred in the St. Avold region, mostly from the U.S. Seventh Army's Infantry and Armored Divisions and its Cavalry Groups. St. Avold served as a vital communications center for the vast network of enemy defenses guarding the western border of the Third Reich. The memorial, which stands on a plateau to the west of the burial area, contains maps with narratives and service flags. On each side of the memorial stretch the Tablets of the Missing . . . 444 names.

Garmisch—Partenkirchen, Germany

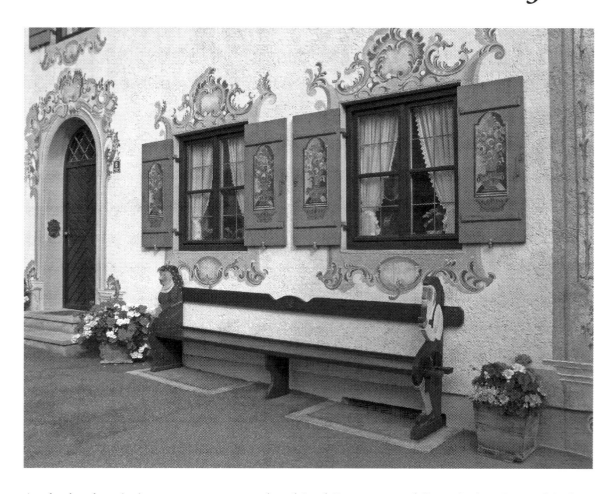

As the hyphen in its name suggests, the chic skiing resort of Garmisch—Partenkirchen was originally not one alpine village but two, which faced each other across the Partnach stream and were united in a shotgun wedding in time for the 1936 Winter Olympics. The Games were an enormous success—so much so that the town was slated to host the 1940 Winter Games. In the event, of course, war intervened and the 1940 Games didn't take place, but Garmisch-Partenkirchen has been on the international winter-sports map ever since. The resort is the venue for the 2011 FIS Alpine World Ski Championships.

Though any clear distinction between Garmisch and Partenkirchen has long since vanished, the two halves of the town do have sharply contrasting characters: Garmisch is lively and international, while Partenkirchen better preserves its original alpine charm. Looming over them both is the Zugspitze, at 2962 Germany's highest mountain. In summer, the town's mountainous setting attracts hikers and climbers.

Burg Gutenberg and Church—Balzers, Liechtenstein

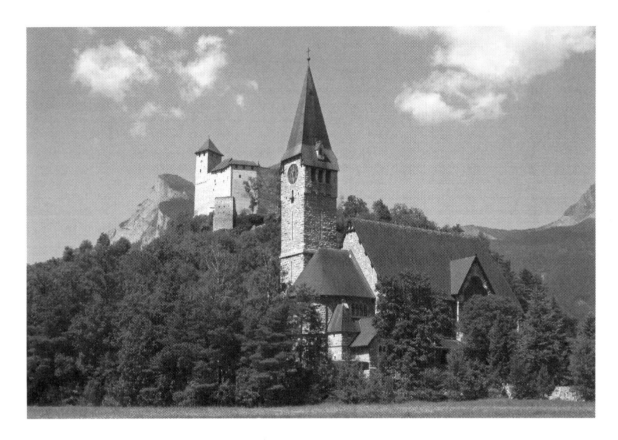

Gutenberg Castle was first mentioned in writing in 1263; it was presumably built in the 11th century. It belonged to the barons of Frauenberg in 1305. It was transferred to the dukes of Austria in 1314 and remained in Austrian possession for more than 500 years. In 1750, it was left to decay. In 1905, the sculptor Egon Rheinberger from Vaduz purchased the ruins and expanded the castle into its current form between 1906 and 1910 according to his own plans. For several years, a restaurant was run in the castle. Today, the castle belongs to the State. It has been restored in recent years, so that the interior and exterior spaces have been used since August 2000 for cultural and social events.

St. Nicholas´ Parish Church construction at the eastern foot of Gutenberg was completed in 1912. It is a neo-Romanesque, vaulted church with a single nave and a semicircular apse. The Vienna architect Gustav von Neumann drafted the plans. The construction of the church was donated by Prince Johann II (the Good) in commemoration of his 50th jubilee. The old church was demolished; only its tower still stands today which is an amazing sight to see.

Chateau Fontaine-Française—Fontaine-Française, France

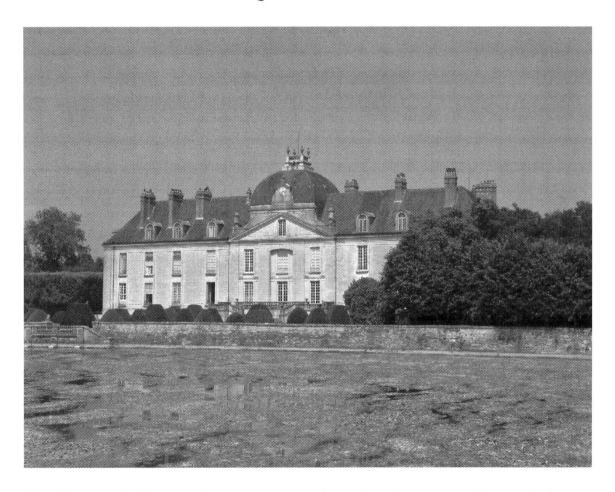

The Chateau de Fontaine-French is a castle located in the center of Fountain-French (Cote-d'Or) Burgundy. In classical architecture; the Chateau de Fontaine-French has kept some of the old fortress walls and sharp and symmetrical shapes. It consists of a central main building flanked by two wings on the court. A dome surmounts the central portion bounded by two avant-corps. It is terminated with a patio umbrella, and has two clocks. The facade facing the courtyard was once adorned with family crests St. Jullien. Hammered during the Revolution, they were replaced in the late nineteenth century by the Chabrillan family. This is a tower guarded by a bear paw, all flanked by two crowned lions.

This beautiful castle, the outbuildings called Petit-Chateau and the enchanted park have been classified a historical monument since November 12, 1945.

Lake Carezza—Dolomites, Italy

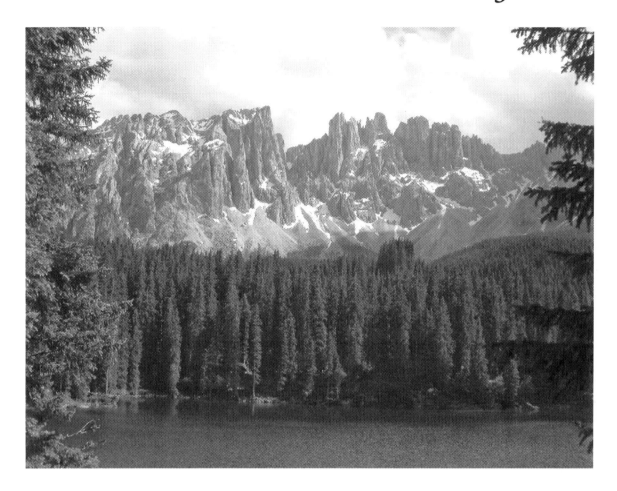

In the western Dolomites, only six kilometers from Nova Levante, there is a small, emerald green mountain lake, in which the Catinaccio and Latemar are reflected: Lake Carezza. Due to its impressing colors, in Latin language it is called "Lec de Ergobando" (Rainbow Lake). But its colors are not the only reason. According to legends, once upon a time there was a beautiful mermaid living in the lake, which wizard Masaré was in love with. In order to seduce her, the Lanwerda advised him to dress up as a jewel merchant and throw a rainbow from Catinaccio to Latemar. That was what he did, but he forgot to dress up. That is why the mermaid detected him and forever disappeared in the lake. The wizard was angry and threw all the pieces of the rainbow as well as the jewels into the lake. That's why it still features rainbow colors.

The lake is fed by subterraneous springs from the Latemar Dolomite mountain chain and the water level is constantly changing. The highest level is achieved in spring and the lowest level in October. In summer months the lake is fed by the snow melt. In the winter; the "Fairytale Lake" is frozen and covered with snow.

Cape of Formentor—Pollenca, Majorca

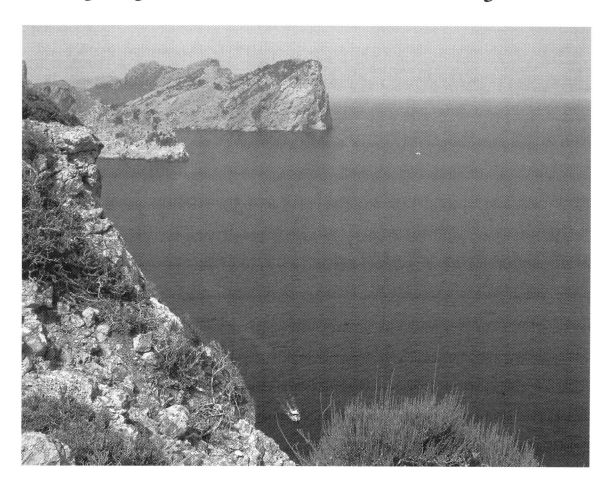

Cape de Formentor forms the eastern end of Majorca's Formentor peninsula. The Majorcans also call the cape the Meeting Point of the Winds. Cape de Formentor is a spectacular bluff, located on the northernmost point of the Balaeric Island, Majorca. Its highest point Fumart is 384m above sea level. It has many associated bays, including Cala Fiquera, Cala Murta and Cala Pi de la Posada.

The 13.5 kilometer street which runs from Port de Pollença to Cape de Formentor was built by the Italian engineer Antonio Paretti. His masterpiece on Majorca, however, was the snake to Sa Calobra. Instead of being overwhelmed by what stood in his way on the cliffs, Parretti observed the Tramuntana winds and understood; where the slope was too steep, he made a curve. When he had to remove part of the cliffs, he placed the waste in other places where it was needed. The results were the two streets, which are nestled together in the mountains like abandoned silk ribbons. The northern western-most end of the Majorcan Island was formed quite bizarrely by the wind and water over time.

Church of the Assumption—Lake Bled, Slovenia

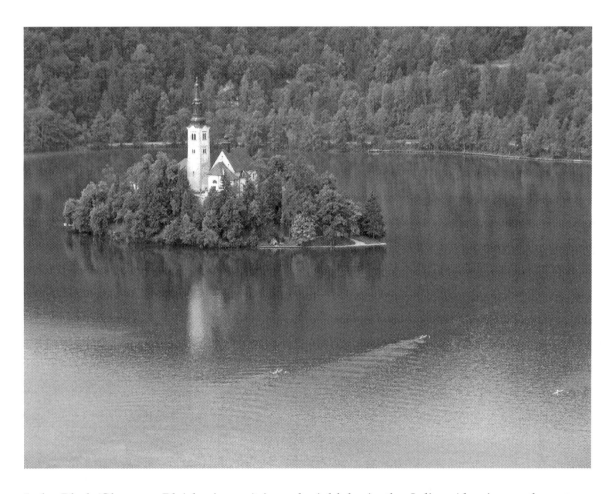

Lake Bled (Slovene: Blejsko jezero) is a glacial lake in the Julian Alps in northwestern Slovenia, where it adjoins the town of Bled. The area is a popular tourist destination. The lake is 2,120 m long and 1,380 m wide, with a maximum depth of 31 meters. The lake is situated in a picturesque environment, surrounded by mountains and forests. A medieval castle stands above the lake on the north shore. The lake surrounds Bled Island; the only natural island in Slovenia. The island has several buildings, the main one being the Pilgrimage Church of the Assumption of Mary, built in the 15th century, where weddings are held regularly. The church has a 52-metre tower and there is a stairway with 99 steps leading up to the building.

The lake is also well known among rowers because it has very good conditions for the sport. It hosted the World Rowing Championships in 1966, 1979, and 1989. It will host the World Rowing Championship again in 2011.

Zugspitze with Flags—Garmisch, Germany

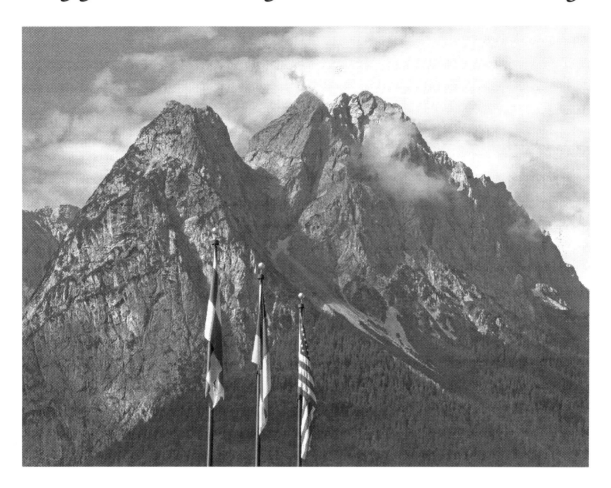

Enjoy unforgettable experiences up high on the roof of Germany. With an altitude of close to 3,000 meters (10,000 feet), the Zugspitze isn't just the highest peak in Germany. It also boasts the highest ski area with 22 kilometers (15 miles) of perfectly groomed runs with reliable snow cover; plus Germany's only glacier - guaranteed natural snow. Ambitious sports lovers, sun worshippers, romanticists or nature lovers; on top of the Zugspitze at an altitude of just fewer than 3,000 meters (10,000 feet) will tantalize everyone's taste. Experience seven months of snow; the best panoramic views of the white powdered Dolomite Mountains of Italy and the Swiss Alps as well as the best winter snow fun on the Zugspitze.

Spoil yourself with a sunbath on Germany's highest sun deck at no extra cost. You will be completely overwhelmed by the matchless 360° panorama across a total of 400 peaks in 4 different countries and enjoy the mountain experience—adventure, a breathtaking view and the freshest and purest alpine atmosphere.

Santorini at Sunset—Santorini, Greece

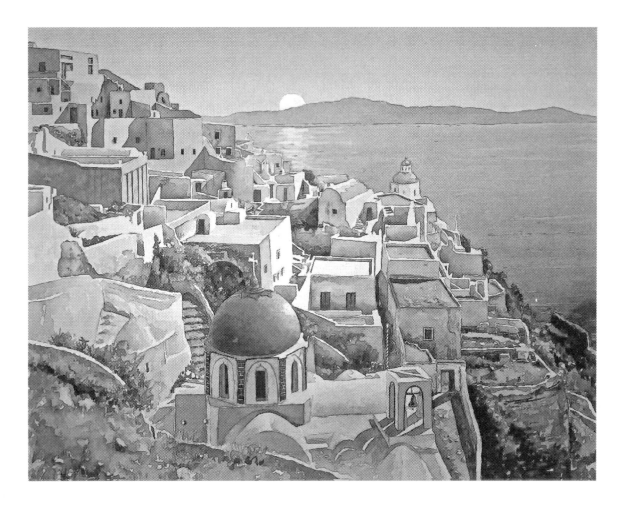

Santorini sunset: Santorini is one of the best places on earth as far as sunset viewing is concerned. In fact few places can match the sheer beauty of Santorini's sunset views. Visitors to the island fall in love with the bewitchingly beautiful sunsets that can be savored from many vantage positions on the island. Most visitors to Santorini agree those sunsets; when viewed from Santorini, makes for a truly surreal experience.

The towns and villages of Santorini are dotted with buildings that have been built after the catastrophic 1956's earthquake. Many of the older buildings collapsed in the earthquake. The newer buildings include hotels and restaurants that have been built mostly on the cliffs, as to provide visitors and residents alike with truly mesmerizing views of Santorini's natural beauty and sunsets. Due to the fact that the romantic Santorini sunset is so potent couples prefer to spend the late afternoons in the company of each other and accordingly the hotels and restaurants have made the necessary arrangements exclusively targeted to attract couples who come in droves from all over the world just for the view.

La Petite France—Strasbourg, France

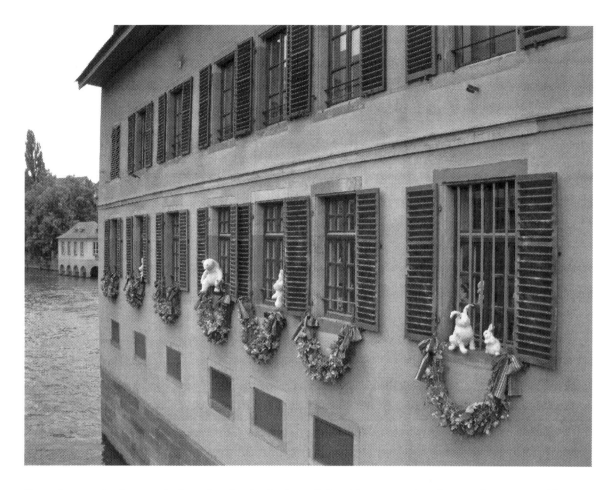

Strasbourg is the capital and principal city of the Alsace region in north-eastern France and is the official seat of the European Parliament. Located close to the border with Germany, it is the capital of the Bas-Rhine department. Strasbourg is the seat of several European institutions such as the Council of Europe (with its European Court of Human Rights, its European Directorate for the Quality of Medicines and its European Audiovisual Observatory) and the Euro-corps as well as the European Parliament and the European Ombudsman of the European Union.

Strasbourg's historic city centre, the Grande Ile (Grand Island) was classified a World Heritage site by UNESCO in 1988, the first time such an honor was placed on an entire city centre. Strasbourg is fused into the Franco-German culture and although violently disputed throughout history, has been a bridge of unity between France and Germany, especially through the U of Strasbourg, currently the largest in France, and the coexistence of Catholic and Protestant culture.

Burg Satzvey—Satzvey, Germany

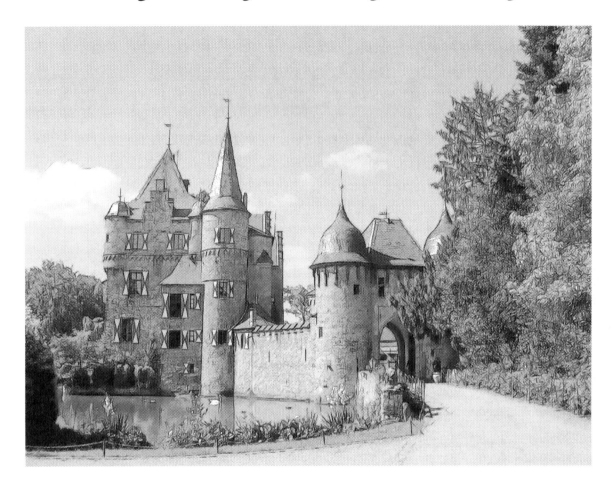

Situated in the western German state of North Rhine—Westphalia, Burg Satzvey intrigues its visitors with its bright and cheerful red and white shutters, which give this majestic structure more of an air of a quaint little cottage. Burg Satzvey is a Wasserburg, which translates to "water castle" in English, which means it has a moat. When looking at this one, visions of teems of dangerous creatures of legend swimming in its murky depths may cross your mind! The castle can be traced back to as early as the mid 14th century. Over the years it was used as a defense for the surrounding area, a command post, and also a home.

This castle is different from many castles that draw tourists in Europe in the way that visitors cannot simply buy a ticket for a tour and go inside. This is because this castle is actually still lived in. So besides the castle itself being a piece of history, the resident family is also a part of that, which makes the whole experience feel even more authentic.

Schloss Neuschwanstein—Hohenschwangau, Germany

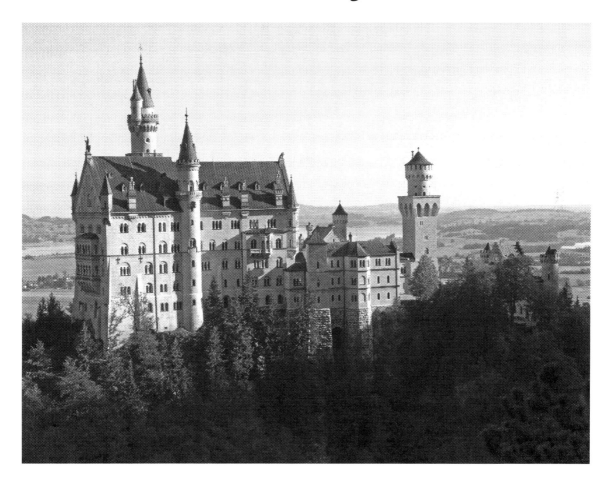

Neuschwanstein Castle is a 19th-century Gothic Revival palace on a rugged hill above the village of Hohenschwangau near Fussen in southwest Bavaria, Germany. The palace was commissioned by Ludwig II of Bavaria as a retreat and as homage to Richard Wagner. The palace was intended as a personal refuge for the reclusive King, but it was opened to the paying public immediately after his death in 1886. Since then, over 60 million people have visited Neuschwanstein Castle. More than 1.3 million people visit annually, with up to 6,000 per day in the summer. The palace has appeared prominently in several movies.

The municipality of Schwangau lies at an elevation of 800 m (2,620 ft) at the south west border of the German state of Bavaria. Its surroundings are characterized by the transition between the Alpine foothills and the Austrian border and a hilly landscape in the north that appears flat by comparison.

Schloss Wimmis and Church—Thunersee, Switzerland

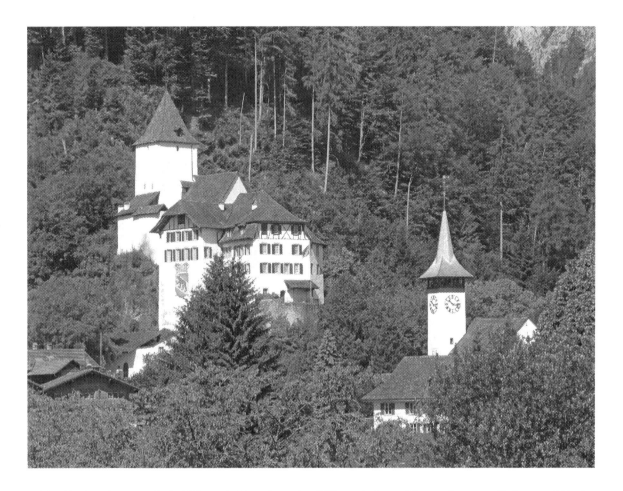

This distinctive castle is Wimmis' landmark. Wimmis is a village close to Spiez and Lake Thun; at the entrance to the Simmental and is flanked by two excursion mountains, the Stockhorn to the north and Niesen to the south. The Romans erected a watch tower at the Burgfluh, site of the distinctive Wimmis Castle. The church and castle are believed to have been built in the 9th century. The first lord of this strategically important castle guarding the entrance to the Bernese Oberland branch valleys was Baron Rudolf von Strattligen.

The castle compound was expanded continuously throughout and beyond the Middle Ages. The fortress became a castle in the 17th century. Wimmis Castle was built in the central European style, in marked contrast to the local Thun Castle.

Taufers Knights Castle—Valle Aurina, Italy

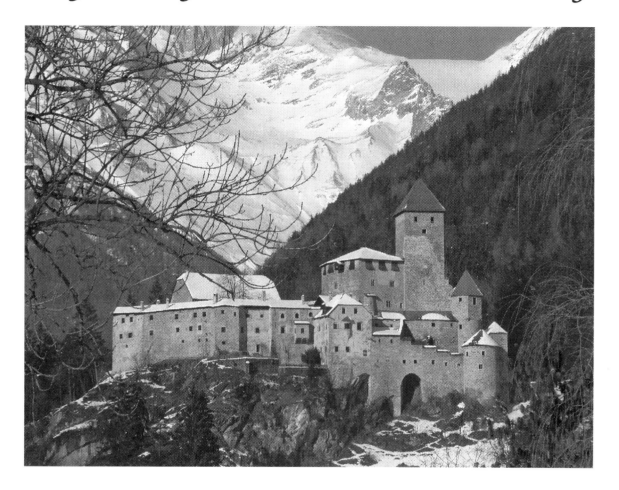

As early as 1136 a noble-free family named Taufers built a new; generously arranged lord house, whose donjon with an attached living tower was constructed against the mountainside, as this was thought to be the possible attacking side. The powerful Taufers Castle (Burg Taufers) is a dynastic seat of the Barons of Taufers with impressive and interesting fortified grounds. Another great hall (later used as a grain storage room) is located at a secured area in the western part of the castle. The naturally given construction space is delimited by a surrounding curtain wall where there are different living complexes attached to it.

Burg Taufers has been in the possession of the Südtiroler Burgeninstitut since 1977. The entire furnished and well preserved castle numbers among the greatest and most beautiful castles of the entire Tyrolean region. Of the sixty-four rooms of the castle, around two dozen are paneled. In the castle chapel, there are frescoes of extraordinary value from the school of Pacher.

Castell de Capdepera—Capdepera, Mallorca

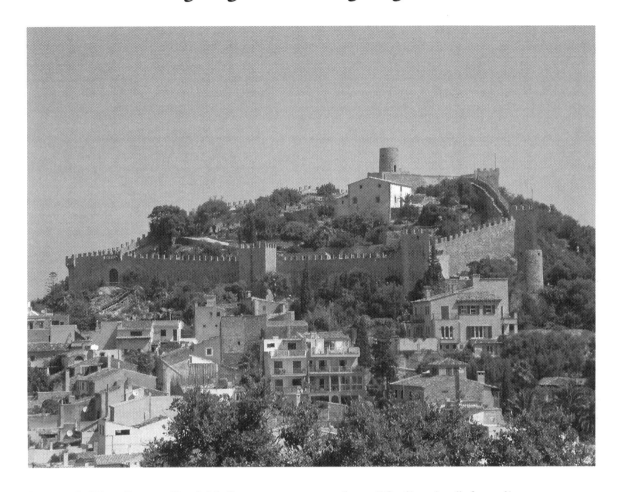

In 1300 King James II of Mallorca pronounced an "Ordination" founding; amongst others, the town of Capdepera. He commanded the public, who lived scattered around the area to build a walled area for them to live in. The area would be built around the watch tower of Miquel Nunis, built on a strategic hill that dominated the surrounding land and had a view of the channel that separated Mallorca and Menorca. First the church and a cistern were built. The construction of the walls of the town was finished at the end of the 16th century, incorporating later the towers to improve the defense of the fortress. The church was extended from the 16th to 18th centuries and inside there is a carving of Christ from the 14th or 15th century, the Gothic statue of the Verge de l'Esperanca and the patron Saint of Capdepera, venerated in the 16th century.

A large number of the villagers of Capdepera were not in favor of abandoning their land to live within the fortified walls, known popularly as the Castle of Capdepera; therefore all the villagers were ordered to be locked inside the fort.

Schloss Paffendorf—Paffendorf, Germany

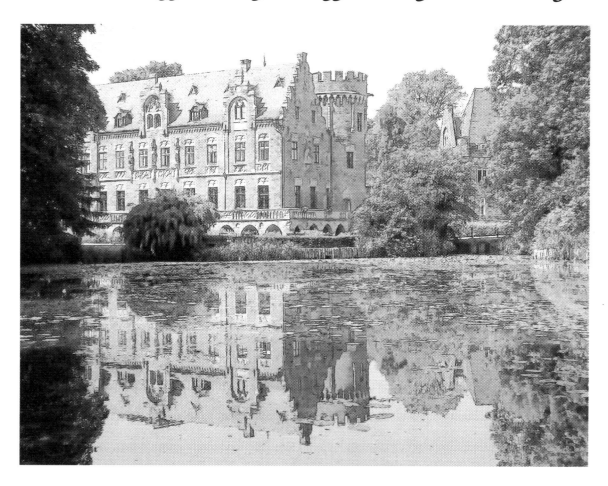

The castle Paffendorf Bergheim in the Rhine-Erft is now a popular tourist destination. The building was built in 1531-1546 on the ruins of a previous building. It is surrounded by a large moat, which was formerly supplied with water from the Erft River. In the 19th century, Castle Paffendorf was rebuilt in the Gothic Revival style with turrets, battlements, balustrades and balconies.

The castle park includes 8 acres with many old trees and gardens. There are also extensive areas of water and a small bog. The landscaped garden was added in 2004 in the streets of garden design between the Rhine and Meuse. The castle houses a permanent exhibition on the theme "Rhenish Lignite". It consists of a previously used agriculture bailey and a mansion. The permanent exhibition is on the first floor of the castle. Another exhibition; which changes frequently, is next to the bistro in the "Gallery Schloss Paffendorf". A beautiful forest trail in the park guides visitors around the flora, garden and the Tertiary.

Window Flowers—Predjama Castle, Slovenia

Predjama Castle (Predjamski Grad) is a Renaissance castle built within a cave mouth in southwestern Slovenia. It is located approximately 11 kilometers from Postojna. The castle was first mentioned in the year 1274 with the German name Luegg, when the Patriarch of Aquileia built the castle in Gothic style. The castle was built under a natural rocky arch high in the stone wall to make access to it difficult. It was later acquired and expanded by the Luegg noble family, also known as the Knights of Adelsberg.

The castle became known as the seat of Knight Erazem Lueger, owner of the castle in 15th century, a renowned robber baron. Fleeing from the revenge of the Holy Roman Emperor Frederick III, Erazem settled in the family fortress of Predjama. The Imperial forces sent Andrej Ravbar, to siege the castle. A headstrong and rebellious knight, Erasmus rebelled against the Austrian emperor Fredrick III and eventually killed his kinsman. After a long siege, Erazem was betrayed by one of his own men and killed.

Burg Eltz—Moselkem, Germany

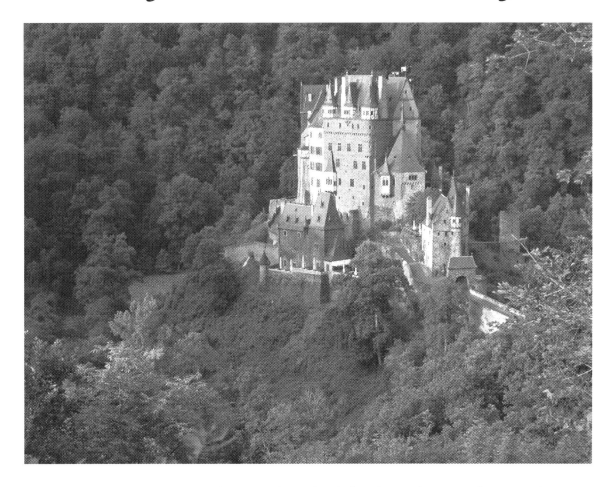

Burg Eltz is a medieval castle nestled in the hills above the Moselle River between Koblenz and Trier, Germany. It is still owned by a branch of the same family that lived there in the 12th century, 33 generations ago. The Rübenach and Rodendorf families' homes in the castle are open to the public, while the Kempenich branch of the family uses the other third of the castle. The castle is surrounded on three sides by the Elzbach River, a tributary on the north side of the Moselle. It is situated on a 70 m rock spur, on an important Roman trade route between rich farmlands and their markets.

The castle is a so-called Ganerbenburg, or castle belonging to a community of joint heirs. This is a castle divided into several parts, which belong to different families or different branches of a family; this usually occurs when multiple owners of one or more territories jointly build a castle to house themselves. Only a very rich medieval European lord could afford to build a castle on his land; many of them only owned one village, or even only a part of a village.

Schloss Sigmarigan—Sigmarigan, Germany

Sigmaringen Castle was the princely castle and seat of government for the Princes of Hohenzollern-Sigmaringen. Situated in the Swabian Alb region of Baden-Württemberg, Germany, this castle dominates the skyline of the town of Sigmaringen. The castle was rebuilt following a fire in 1893, and only the towers of the earlier medieval fortress remain. Schloss Sigmaringen was a family estate of the Swabian Hohenzollern family, a cadet branch of the Hohenzollern family, from which the German Emperors and kings of Prussia came. During the closing months of World War II, Schloss Sigmaringen was briefly the seat of the Vichy French Government after France was liberated by the Allies. The castle and museums may be visited throughout the year, but only on guided tours.

The first castle at Sigmaringen appeared during the end of the Early Middle Ages, during the early 11th century. The castle was first mentioned in 1077 following the unsuccessful siege of Burg Sigmaringen by Rudolf of Rheinfelden in his fight against the King of Germany, Henry IV.

Hopfensee—Bebele-Fussen, Germany

Hopfensee is a lake in Bayerisch Schwaben, Bavaria, Germany. At an elevation of 784 meters, its surface area is 194 acres. The maximum length of the lake is 2 km, and its circumference is 7 km. It lies north of Fussen in Ostallgau. Its maximum depth is 10 m. It was formed by the Lechtal glacier and is one of the remains of a larger Fuessener See. The Hopfensee-Ach flows out of the lake and into the Forggensee. On the northeast shore is the resort Hopfen am See. There is a campground on the east shore. Besides swimming as early as the end of May, boating, sailing, and wind surfing are popular activities.

The Allgau Alps are a mountain range in the Northern Limestone Alps, located in Bavaria in Germany and Tyrol and Vorarlberg in Austria. The range lies directly east of Lake Constance. The Northern Limestone Alps are located north of the Central Eastern Alps located in the alpine states of Austria and Germany.

St Nicholas Church—Valdurna, Italy

The parish church of St. Nicholas in Valdurna contains the paintings that the "school of Bolzano" inspired by Giotto left on the vault of the presbytery in the early 400 century. Valdurna is a secondary branch of the Sarntal (German Sarnthein) valley. At the head of the valley; at an altitude of 1570 meters above sea level, there lies the village and the homonymous lake Valdurna, 15 km from the capital of Sarnthein.

It takes just over an hour to walk around the lake and protected territory, which is accessible only on foot. The Talvera River crosses the valley of Sarnthein; the largest extension through the tourist area of Trentino Alto Adige. It is less well known and it is in the heart of the Sarentine Alps. It is inhabited exclusively by people whose mother tongue is the German language. Three hundred kilometers of trails are properly kept and reported, applicable to a large extent from early June to late September. They have preserved these traditions for the isolation for thousands of years due to difficult road access.

Vaduz Castle—Vaduz, Lichtenstein

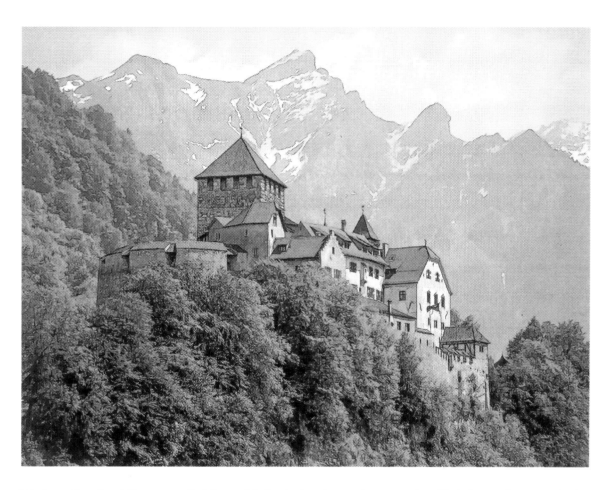

Vaduz Castle (German Schloss Vaduz) is the palace and official residence of the Prince of Liechtenstein. The castle gave its name to the town of Vaduz, the capital of Liechtenstein, which it overlooks from an adjacent hilltop. The earliest mention of the castle can be found in the deed of the Count Rudolf von Werdenberg-Sargans for a sale to Ulrich von Matsch. The owners; presumably also the builders, were the Counts of Werdenberg-Sargans.

The tower stands upon a piece of ground of about 12 x 13 m and has a wall density on the ground floor of up to 4 meters. The original entrance lay at the Hofzijde at an 11 m height. The chapel St. Anna was presumably built in the Middle Ages as well. The main altar is late-gothic. In the Schwaben War of 1499, the castle was burned by the honor-bound of Switzerland. At that time; Charles VI, Holy Roman Emperor combined the countship with the Lordship of Schellenberg and was purchased by the Liechtensteins in 1699 to form the Principality of Liechtenstein. The Liechtenstein family acquired Vaduz Castle in 1712.

Hohe Schloss Fussen—Fussen, Germany

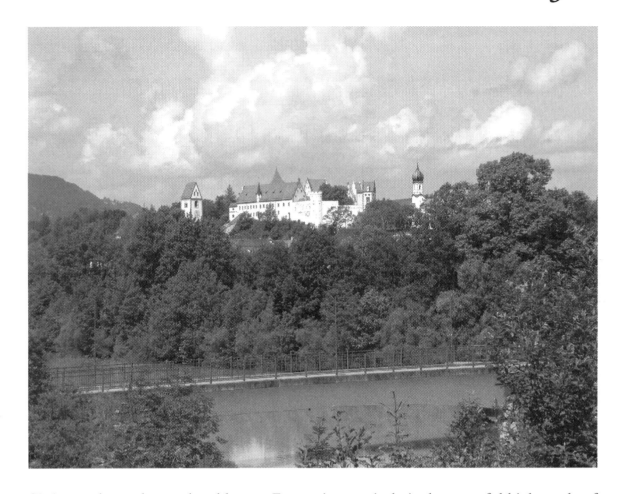

Sitting enthroned over the old town Fussen impressively is the graceful high castle of Fussen; which is one of the most photographed monuments in the area. Much has been speculated over the early history of the castle; however, the further history dates back, the more complicated it gets. As of 1313; the cloister and the town were subordinate to the Augsburg bishops, however. Bishop Friedrich II of Zollern had the high castle enlarged to the shape of today which provides a remarkable illusion painting. The high castle was and still is today, part of the biggest and most important medieval castle complexes of Swabia.

A balanced collection of late Gothic, mostly Swabian painting presents itself in six rooms of different character in the second upper floor of the high castle today, completed by some paintings from the end of the 16th century. The "great hall"; with its coffered ceiling carved splendidly, served as a representative hall in which emperor Maximilian I was frequently greeted with Bavarian works of art.

Schloss Tarasp—Sparsels, Switzerland

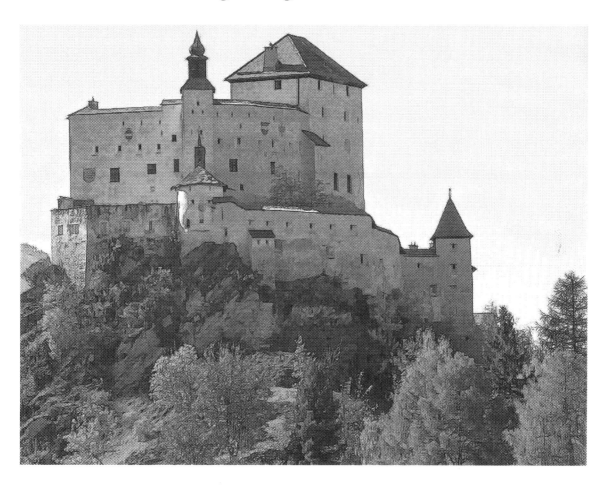

Tarasp Castle lies on a cone-shaped rocky hill in the scattered settlement Tarasp in the Swiss canton of Grisons. As one of the most impressive castles in Graubünden it is considered a symbol of the lower Engadine and is visited annually by approximately 15,000 people. The Castle Hill is located on a terrace on the right side of the Inn. At the base of the castle lie the hamlets of Sparsels, Fontana, Florin and Sgne and the beautiful Tarasp Lake.

The castle dominates the lower Engadine from the upper castle; a fortified castle with lower access. The upper castle consists of the main castle, a southern and a north wing, battlements and the cistern and the residential buildings grouped around a courtyard. In the castle, a terrace extends north of the upper Castle which consists of watch-house, powder towers, gatehouse, chapel and campanile and comprises about 100 rooms. Prehistoric graves found in the witches and Sparsels stones at Sgne show that the area was settled before the construction of the castle. Coin found suggests that there was a Roman watchtower close to the castle hill.

Dinklesbuhl Castle—Dinklesbuhl, Germany

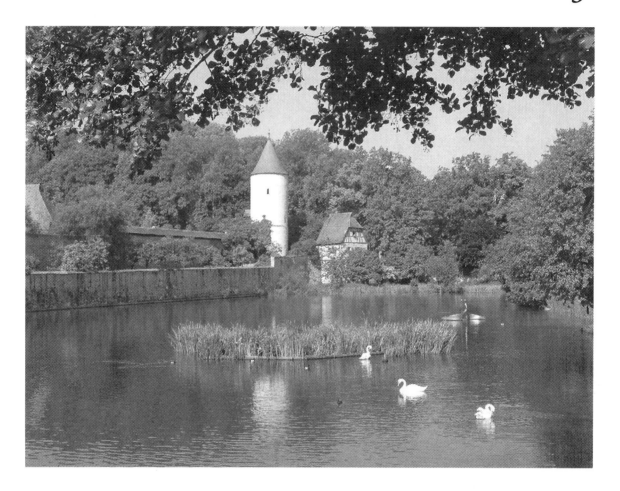

Nags Pond is located in Dinklesbuhl and is simply enchanting! Every day of every year, guests from all over the world are overwhelmed by the charms of one of Germany's most beautiful medieval towns. Wherever they look, visitors encounter living history rather than the raucous attractions of a fun park. But Dinklesbuhl is more than just a fairy-tale town bearing witness to the Middle Ages, and it's more than an important magnet for tourists situated in the heart of the Romantic Road. Dinklesbuhl is an attractive location for business, it has good educational facilities, and it is a popular residential area. Dinklesbuhl is the headquarters of the Romantic Road Association, and its international flair contrasts with its picturesque tranquility in the Franconian-Swabian countryside.

The high quality of life which our town offers is reflected in its diverse cultural events, the attractive variety of leisure activities available, its intact environment and the excellent range of services provided. It is to young people and families in particular that we try to give a perspective, focusing on building development.

Schloss Eisenbach—Eisenbach, Germany

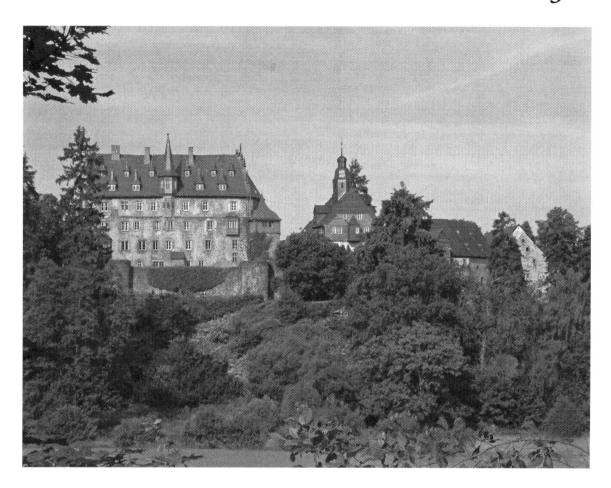

The castle, owned by the Eisenbach family, was mentioned documentarily in 1217 for the first time. Destroyed in 1269 by Prince Abbot Leipolz of Fulda, it was built up again within 10 years by the Fief Knights of Eisenbach. In 1429, the Barons of the Riedesel family got Eisenbach castle after the final death of the Eisenbach family. They took care of this possession for over 500 years. The most powerful lords of the manor in the Lauterbacher area at that time were the Cloister and the Abbey of Fulda.

To be able to perform their power, they were dependent on worldly overseers because as spiritual power, they were not allowed to perform any power over life and death. The overseers were the Barons of Ziegenhain, who were allowed to install sub-overseers in different judicial districts. The Sirs of Wartenberg were the oldest overseers in the Lauterbacher area. Between 1100 and 1250, thousands of castles were built throughout Germany where regional Barons and Knight Families were allowed to mark off their domains with castles.